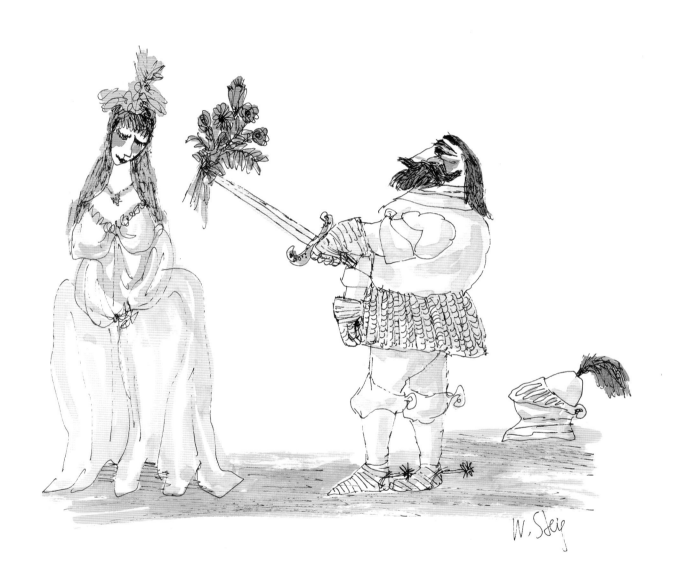

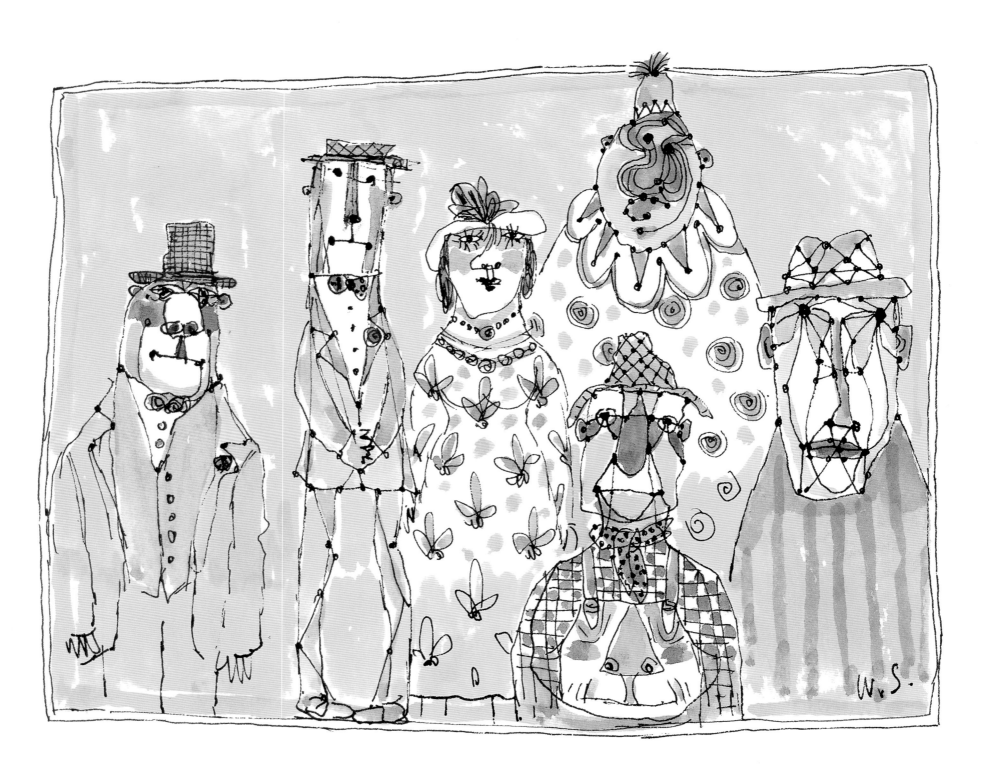

THE WORLD OF
William Steig

Lee Lorenz

INTRODUCTION BY
John Updike

ARTISAN NEW YORK

CONTENTS

INTRODUCTION

by JOHN UPDIKE

I own a Steig. It hangs in a room where I work, and every time I look at it it makes me happy. It shows a woman rocking far back in a chair with thick rockers shaped like the crescent moon, laughing while the crescent moon, posed points down above her face, laughs back. Or maybe she is laughing back at the moon. The heavenly presence seems male, so there is a sexual current as well as a cosmic one. I saw the drawing—too small and sly to be a full-fledged cartoon, too big and suggestive to be a mere decorative "spot"—in a 1976 issue of *The New Yorker,* loved it, wrote to the artist, and received an arrangement to buy, at a discount, the original from his gallery.

My psyche is such that looking at most graphic art makes me happy, especially art that has been reproduced or intended for reproduction. An original work is a double dose of happiness. Steig's rocking woman is jubilant, and the moon jubilates with her.

Steig's cartoons do not only deliver a joke but make us reflect upon the nature of reality. There is a psychological and philosophical resonance in Steig that has long set him apart in *The New Yorker.* His ideas are all his own; his drawings are extensions of his life. That life, as you will read in the text of this dazzling album, was nurtured in an emotional, demonstrative, and creative family and has been sustained in a succession of creative domestic settings. His siblings, wives, and offspring have without exception been creative artists of some sort, and Steig, for all his insight into stunted and inhibited children, seems to be one of those adults in whom the creative child has never met discouragement. He has the

dauntless energy of prelapsarian innocence. An Edenic nudity gaily haunts him.

His art has moved from more or less commercial cartoons into symbolic and expressionistic realms ever closer to the well-springs of experience, such as his late-starting but fast-accumulating shelf of children's books, and those recent *New Yorker* spreads in which he depicts, in a childish style of unnerving directness, such elemental narratives as those of Greek mythology, Genesis, Exodus, and fairy tales. There is no overt satire in these depictions, but rather a bliss of simple belief, a seeing as if for the first time the narrative images with which children, at least in Steig's childhood, were primed for

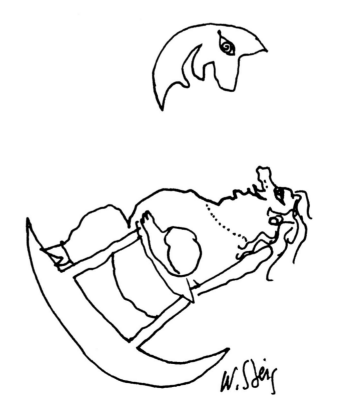

existence in Western culture. The daydreams of "Small Fry," their dreams of glory, were what made his name as a cartoonist, and the surreal drawings of *The Agony in the Kindergarten* were perhaps his most brilliant breakthrough into a purer kind of art, but his representations of childhood have always implied a continuity with adult experience; children are not a zoo of entertainingly exotic creatures but an array of mirrors in which the human predicament leaps out at us.

Freud thought that normal human unhappiness was the best that psychotherapy could bring us to, whereas Steig, the child of Socialists, has wider and higher hopes. In his introduction to *Dreams of Glory*—perhaps the most idealistic and thoughtful preface a cartoonist ever addressed to his public—he describes his own dream, which is to be "such a completely mobile being that I can do and feel whatever the human body and spirit are capable of." Glory, not attained only in dreams but accessible to clear eyes and a susceptible heart, is the essence of his later *New Yorker* covers, colored with glorious freshness and drawn as if with the unpremeditated certainty of a child's crayoning.

Steig's first contribution to *The New Yorker* came in 1930, and Lee Lorenz's biographical account makes it clear that the long association was not free of conflict. Steig's uninhibited thrust and unabashed concern with profound humanistic issues more than once overflowed Harold Ross's somewhat narrow and prudish conception of what his magazine should be. But however strained, the relationship held, and indeed strengthened under the editorship of William Shawn and Robert Gottlieb. Steig—unlike Arno, Price, and Addams, to name three—found outlets and creative satisfaction outside the magazine, notably in his children's books and the books of "symbolic" drawings. But it is hard to imagine *The New Yorker* in its glory not containing Steig's sly glimpses into the subconscious, whether through the eyes of a child or through winsome permutations—like my rocking woman and laughing moon—of sexual relations. He gave the cartoon chorus a baritone of seriousness, of hard-won life-wisdom, and in recent decades has struck a purely lyric note like the warble of a panpipe. He was, in those citified, civilized pages, something of a wild man, but one who knew things better not forgotten, and whose freedom all could envy.

For years, Steig has drawn directly in ink on paper, without a preliminary pencil sketch. He professes his favorite artist to be Picasso, a model of confidence, abundance, and health of frankness and experiment. The aspiration to health disposes Steig to the organic. Their appetite for love and admiration shapes his figures like flowers yearning in sunlight. It has been pointed out that there is little modern machinery in his world, but as in a magnified garden there are bugs—giant bugs—and monsters of many sorts, some of which can be tamed.

Lee Lorenz, in assembling an album covering all of Steig's oeuvre, suffers an embarrassment of riches; he has moved through it with the sure eye and hand of a *New Yorker* art editor. Such a compilation serves to celebrate an original who has endured, who has taken his talent in one direction after another and found new territory deep in his old age. Steig's art is not just testimony to his love of life but robust evidence of the necessary interaction between art and life, reality and fantasy. Blake is another touchstone for him, Blake the singer of satisfied desire and the prophet of man unshackled. Children in their dreams of glory are free, free to create omnipotent selves, and my laughing, rocking woman, even with her unfortunately warty nose, is satisfied, free to flirt with the moon.

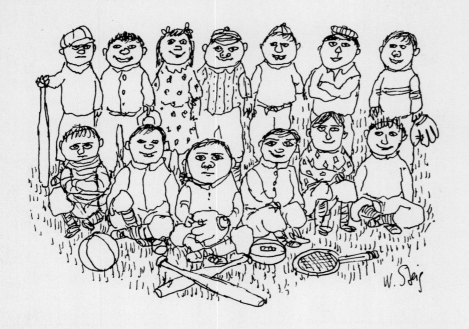

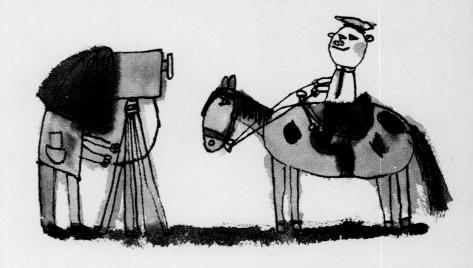

A FAMILY ALBUM

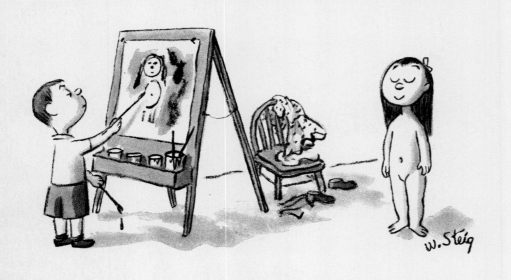

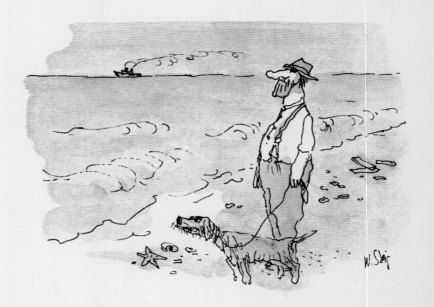

"Actually, I never intended to be an artist."

As he speaks, William Steig cocks his head to one side, and smiles a shy, conspiratorial smile. His features combine the mischievousness of a street-smart kid with the sea-worn cragginess of an old salt—one of his classic "Small Fry" chiseled into the side of Mount Rushmore.

"My ambition as a kid was to run away to sea. I loved reading adventure books, and I remember stories by a writer named Daniel O'Brien about the South Seas islands. That was my dream, leaving home and sailing off to the South Seas. In fact, when I was about fifteen, I *did* run away from home after a row with my dad. He was holding forth at the dinner table—he was a great talker. My mom and my three brothers just ignored him, but I was egging him on, 'You tell 'em, Pop!' Finally, he told me that if I piped up one more time, he'd pop *me.* I did, of course, and he threw a coffee cup my way. He missed, but I stormed out the door. I decided to run off to join the marines. I had a quarter in my pocket. We lived way up in the Bronx and the recruiting office was down at the Battery. I spent a dime on an Everyman's Library book to read on the subway, and a nickel on the fare. I spent the night in Penn Station. After the marines turned me down in the morning, I spent my last dime on a hot dog, so I had to walk all the way back to 170th Street. When I

The Eternal Sea

From the time he was a boy growing up in the Bronx, Steig was fascinated by the idea of running off to sea. The theme of leaving home recurs throughout his art, from the antics of "Small Fry" to the more pensive poses of his old salts.

Amos & Boris

finally got home, my mom and dad hugged and kissed me and we all cried. We were a very emotional family."

And an extremely creative one. Steig married his first wife, Liza, in 1936, and his parents continued to share his home even after his children were born— Lucy in 1940 and Jeremy in 1942. Lucy remembers an extended household bubbling with creative excitement.

"Sometimes we would all gather together around the kitchen table and paint. Grandpa was great at

Zeke Pippin

Nov. 28, 1983

Price $1.50

THE NEW YORKER

making things. I remember a whole circus he created out of cardboard and bits of wood. Friday nights were like weekly family reunions. Dad's brothers would show up with their wives or girlfriends. The conversation always started with politics, but by the end of the evening they'd covered everything—art, music, philosophy, and, of course, psychoanalysis.

"Grandma was a terrific cook, and for the occasion she always made something special. In the summer it was fruit soup. I used to sit with her in the kitchen while she cooked. She was a marvelous storyteller and could make a thrilling adventure out of a trip to the butcher. Sometimes she reminisced about the Old Country. As a child she had been chosen to spread flowers in the path of Archduke Ferdinand when he visited her hometown."

Jeremy, a world-class jazz flutist, recalls days and nights filled with song: "Grandpa loved opera, but we had all kinds of music. Dad was sort of a jazz buff and he had records of all his favorites . . . Ellington, Cab Calloway, Billie Holiday, and Leadbelly, the blues singer. My sister Lucy played the piano, and when I showed an interest in music, Uncle Henry taught me to play the recorder. At bedtime, Dad would read us something like *The Call of the Wild,* and after he turned out the lights, Mom would softly play the piano until we fell asleep."

Every available surface in the large, sun-filled apartment the Steigs occupy in Boston's Back Bay displays some example of the family's artistic genius: carvings and paintings by the artist and his three brothers, paintings by his parents and children, and sculptures and constructions by his wife Jeanne. One

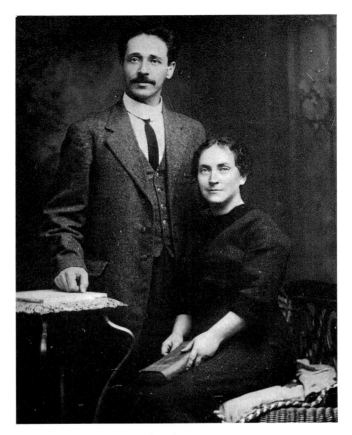

Joseph and Laura Steig

Steig, the son of Socialists who believed most work to be inherently exploitative, was encouraged by his parents to pursue his artistic interests. Every Friday night, the entire extended family would gather and engage in animated discussions.

watercolor by his father, Joe, reveals a verve and assurance worthy of Bemelmans.

"Pop made his living painting houses, and on weekends he used to copy postcards in oil paints. He encouraged all of us to be artists. My parents were

Father

Arrested for attempting to organize unions in his native Lemberg, Joseph Steig was put in prison. Steig remembers stories of his grandmother bringing his father "chicken soup in the clink." After the family immigrated to America at the turn of the century, Joseph earned his living painting houses, and dabbled in oils on weekends.

Socialists and believed that you were being exploited if you worked a regular or ordinary kind of job. And if you were the boss, you were exploiting others. So the idea was to go into the arts. When my brother Henry declared that he wanted to be a dentist, we just laughed him out of it.

"My parents were born in Lemberg, sometimes called Lvov, a small town in what was then part of the Austro-Hungarian Empire. My father's family was Hasidic, but in his teens, he became an atheist and joined the Socialist party. He was locked up for trying to organize a union and his mother used to bring him chicken soup in the clink. He was drafted into the army—every man was obliged to serve three years—and won a couple of medals for sharpshooting. He used to tell great army stories, acting out all the parts. His brother became very religious, but Pop thought he was a coward who was just avoiding the draft. He also had a sister, Clara, who came to the United States and settled in Savannah. She had a heavy Polish accent—Polish was the native language in Lemberg, and German the official language—and I remember her speaking English with a strange combination of Yiddish and Southern inflections.

A Dream of Chicken Soup

Mama and Papa never quarrelled in front of the children.

"When my parents came to America, in 1903, my oldest brother, Irwin, was already two. My dad started painting houses. My mom was a seamstress. A doctor my dad knew was married to an opera singer who became Mom's best client. They settled on Keep Street in Brooklyn. That's where my brother Henry and I were born—my birthday is November 14, 1907. My younger brother, Arthur, was born after we moved to the Bronx. There were two other boys who died in infancy.

"As a dedicated Socialist, my dad spent most evenings at the Second Assembly District meeting house in the Bronx. He was a good-looking guy and had an eye for the ladies. My mom was convinced his political interests were just an excuse to chase women. She used

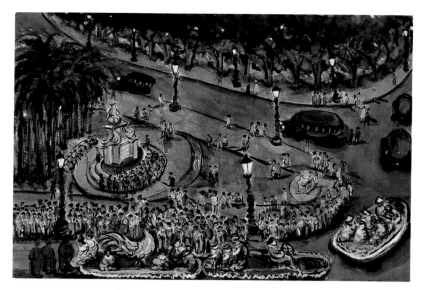

One of Joseph Steig's Scenes from *Rigoletto*

In such spreads as "A La Recherche du Temps Perdu," first published in *The New Yorker* in September 1959, Steig recalled his parents' volatile marriage and his father's love of opera.

Caruso was Papa's favorite singer.

to say, 'I know who those Socialists are,' but, as far as I know, she never caught him. They had a very stormy relationship and fought a lot. Dad would yell and Mom would cry. Then he'd calm down and turn on the charm. Eventually they would kiss and make up.

"Dad didn't have a great education, but he was smart. He would speak in German or Polish at home, especially when he didn't want us to know what he was saying to our mother. But to improve his English he began to read Shakespeare, and I remember him bringing home a set of encyclopedias. And he loved opera. His favorite singer was Caruso. He listened to the

performances on the phonograph, and occasionally he'd get a couple of tickets and take either Mom or one of us kids. He even painted scenes from *Rigoletto.*

"He died of a heart attack at eighty, and for years I dreamed about him every night. I continued to speak of him in the present tense, as if we'd just had dinner together the day before. Then one morning I said to my wife Jeanne, 'Pop didn't look so good last night.' After that I never dreamed of him again.

"I still think about him, though. I remember riding with him in an automobile when I was two. That's how I date things: If it was in Brooklyn, I was two; if it was in the Bronx, I was three or older. I remember Dad rowing us out on the lake in Tremont

Miss Nank had eyes in the back of her head.

Papa was an expert rower.

From the sharp reprimands of a strict kindergarten teacher to boating excursions with family and friends, childhood memories form the basis of much of Steig's art, as evidenced in both the endearing "Small Fry" cartoons and the more experimental drawings of "A La Recherche du Temps Perdu."

Park. I remember my first day of school—they were very strict back then and when I wandered over to the window the teacher, Miss Nank, tied me to my seat. They made the boys and the girls sit on opposite sides of the room, and if you acted up, they punished you by putting you over with the females—the enemy camp. It was all very embarrassing.

"What I don't remember is doing a lot of drawing as a kid, but I did like to write. Just the physical act of writing was pleasurable—it still is. I wrote some stories and at one point I even kept a diary.

"The kids I hung out with formed a club when we were all about ten years old. We called it the Orion Athletic Club, because we considered ourselves all-stars. There was Philip 'Fishy' Paiewsky, Sidney 'Mickey' Mickenberg, Eli Skrilloff, and 'Doc' Øjukavish. When we finally let a girl (Essie Heberman) join, we changed the name to the Orion Athletic and Social Club.

"On Saturdays we would go to the public library, making jokes on the way and kicking each other in the pants. The legend of King Arthur and the knights of the Round Table was a big favorite and we used to act out the stories in elaborate Arthurian language. We also spent a lot of time at the public pool, where I became a good swimmer.

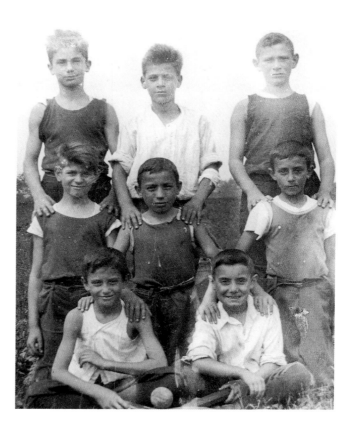

The Round Table

As a member of the "Orion Athletic Club," ten-year-old William Steig (top row, center) would enact elaborate scenes from the legends of King Arthur with his friends.

"By the time I was in high school, my eldest brother, Irwin, had a job reviewing vaudeville acts. We always thought of him as the conservative member of the family. (Henry published short stories, and Arthur had all sorts of artistic talents.) Irwin was terrific at poker and a first-rate chess player. In fact, he was the ranking master in Connecticut. He wrote books on both subjects, and I illustrated them. Irwin used to

That Old Gang of Mine

come home for dinner on Saturday nights and my father, who expected everybody to kick into the family till, used to complain about his not being satisfied with the haul. Pop was not cheap, but anytime any of us earned any money, we were supposed to give most of it back. I used to make 250 bucks a summer as a lifeguard and I handed over almost all of it. One night at dinner, he told us about a dream he'd had that he couldn't figure out. He was riding in a chariot pulled by four horses. My three brothers and I all fell out of our chairs laughing, but he didn't get the joke.

"After I graduated from high school I went to CCNY, where I was on the water polo team. I switched after two years to the National Academy of Design. Henry had gone there full-time, and Irwin had taken some night courses. At the academy, we drew from plaster casts and an occasional live model, but mostly I remember playing touch football behind the building.

Still Life by Laura Steig

"Through a kind of fluke I even spent a few days at Yale. I'd spent my high school summers lifeguarding at some swanky camps, Totem Lodge and The Napanoch Country Club up near Albany. Some of the counselors I knew became famous. Manny Lepofsky changed his name to Manfred Bennington Lee and was co-author of the Ellery Queen books. I also knew Luther Adler then, before he became an actor. He got fired for fooling around with one of the female guests, and I quit in protest. The people at these places were pretty rotten. Once I saved an old lady from drowning and she gave me a dollar. Anyway, I got pretty friendly with a kid from a well-heeled family who was going to Yale. He told me I could stay with his family if I wanted to try the Yale Art School, so I did. His family was very nice to me, but he was always off with his girlfriend and I

"Sh-h-h-h!"

really didn't have anything to say to them. One night when everyone was asleep, I left a note and went home.

"My mom started painting late in life, but she had a real flair. My brother Henry also painted, and he could do everything. He played the saxophone in jazz bands when he was just a teenager. He traveled with a vaudeville act, and I remember he came home from one week's trip and announced, 'Bill, I've gotten laid.' I was so excited and jealous I made him tell me all about it a hundred times. Henry wrote stories about his experiences and sold them to *The New Yorker* and other magazines. In one he described a vaudeville act in which the guy exits from the right side and reappears on the left side after having run behind the curtain. One night he fell while he was running, and the line in Henry's story was 'He had the gobblepipe in his puss when he took the dive.' A gobblepipe is a saxophone. That's the kind of language he used. He was a good cartoonist, and since our stuff was running in the same magazines, he used

the name Henry Anton. In 1941, he published a jazz novel called *Send Me Down* and did a brief stint in Hollywood, which he hated. He painted, sculpted, did photography, and in the late forties got into designing jewelry. He had a store on Lexington Avenue. That famous shot of Marilyn Monroe holding her skirt down

Laura, Steig's mother, began painting later in life. Henry, one of Steig's three brothers, was a musician, writer, and fellow artist. Because some of their work, such as these two cartoons from the November 26, 1932, issue of *The New Yorker*, was published simultaneously in the same magazines, Henry used the pen name "Anton."

"Jim, I'm going to have a baby!"

A precocious reader who influenced his older brother's intellectual development and even introduced him to the works of Picasso, Arthur Steig was also a writer who contributed forewords to several of William's books, including *About People, All Embarrassed*, and *Male/Female*.

over a subway grate shows Henry's store in the background. Today, Henry's jewelry is in museums and is highly prized by collectors. He always thought of me as the wild one, and I thought he was a pain in the pants.

"My brother Arthur was six years younger than me, but we were always very close. He was sort of a prodigy, he read the *Nation* when he was still in the crib. He tipped me off to Picasso—my favorite artist—and was constantly suggesting books to read, and to avoid. He liked to get to the bottom of things. He even worked out an elaborate theory of humor when he was just a teenager. During the Second World War he got a job as a machinist. In six months he was the best guy in the shop. After the war he got fed up with Manhattan and moved with his second wife, Aurora, to southern New Jersey. Arthur designed scarves and when he couldn't find the kind of dyes he wanted, he studied the chemistry of the business and started manufacturing his own. Eventually, he created a whole line of artists colors. Henry was his partner for a while and when he dropped out Aurora filled in. They mixed up the stuff, bottled it, and sold it directly to art stores. Arthur also developed a terrific waterproof drawing ink that you could use in a fountain pen. He used the brand name 'F.W.,' for 'Flow Waterproof,' but to the family it stood for 'Fucking Wonderful,' the stuff was so good. Arthur was an exceptional artist and his work got better as he got older. Most of his best pieces are large line drawings in pen or pencil—usually portraits or still lifes. In my opinion, his stuff is right up there with Matisse and Picasso.

"In addition to artistic and poetic talents, Arthur had the peculiar ability to submerge himself into states of deep reverie during which he experienced something like second sight. He once called me up to say he had seen me surrounded by geese. Sure enough, the day before I had been feeding geese that visited our pond.

"Arthur was a wonderful man. He died in 1989 and I still miss him.

"My son, Jeremy, is also a natural painter, but his first love is jazz. When his debut record came out, one critic said there were three great flutists in the world: James Galway, Jean-Paul Rampal, and Jeremy Steig. He said his first word—'rec,' for 'record'—when he was still

in the crib. I used to play jazz records for him all the time.

"My daughter Lucy is a psychiatrist now, but she was always a first-rate painter. She exhibited professionally for several years before she became a therapist.

"My youngest daughter, Maggie, is an actress and an events planner. She did metal sculpture for a while, and I used to wear one of her rings when I drew."

A long, gallerylike hallway connects the front of the Steig apartment with the artist's studio in the rear. The studio has windows on two sides and is modestly outfitted with a drawing table, a lamp, a telephone, some flat-files, a fax machine—and what appears to be an upended shipping crate equipped with a door. This "crate" is in fact a link to the most significant figure in William Steig's life, the controversial psychiatrist Wilhelm Reich (page 74). The shelves in the storage closet of Steig's slightly disheveled workspace are

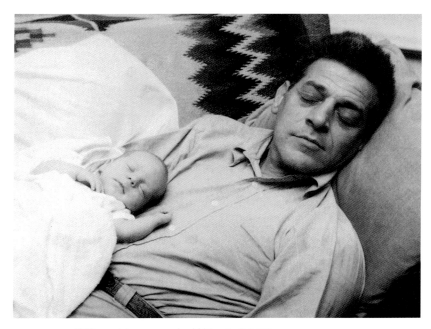

William with two-month-old Maggie (1958)

stacked with drawings, correspondence, and copies of the dozens of books he has published. On the cover of one is a drawing of a street peddler hawking his wares from a horse-drawn wagon. The title, in bold red letters, reads *Man About Town.* In equally large letters in the lower left corner, the author is identified: "By Steig."

"*Man About Town* was my first collection. It came out in 1932 and featured mostly early stuff from *The New Yorker* with some other pieces published in *Judge, Life,* and *Collier's.*

"When the Depression hit, we discovered my old man had put all his savings in the market. Arthur was only in high school, and both Henry and Irwin were already married and on their own. Nobody could afford to have their house painted and my dad told me I would have to support the family. I knew I could draw. I didn't know if I could make any money at it, but it seemed like the best thing to try."

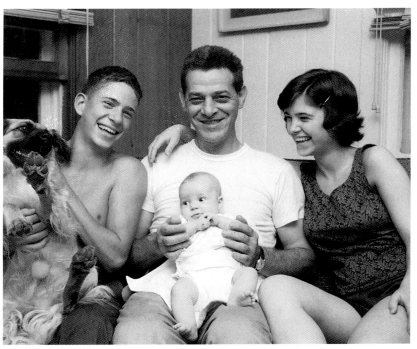

Jeremy, William, Lucy, and baby Maggie Steig (1958)

ARTISTS ALL

In 1945, after William Steig had achieved a certain degree of notoriety due to the publication of his symbolist drawings in such collections as *About People,* the family Steig was presented to the public at the New Art Circle on New York's Fifty-seventh Street. The gallery owner, J. B. Newmann, advertised the show as "The Eight Performing Steigs, Artists All." The exhibit was warmly noted in *Newsweek* magazine with a two-page illustrated review. The eight Steigs represented were Bill and his second wife, Kori Townsend, his brothers Arthur and Henry and their wives, and "Mom and Pop" Steig, Laura and Joseph. (The eldest Steig brother, Irwin, was not represented. He had long since sold out to the world of advertising, and the family had ceremoniously turned his easel to the wall.)

The creative impulse is indelibly printed on the Steig genome, but it also seems to be socially transmitted. Although the three wives were all artistic, they began painting more seriously after they joined the Steig family. Arthur's wife, Aurora, is quoted as saying, "As a Steig, you just *have* to paint, you know."

"Pop" Steig put it this way to the *Newsweek* reporter: "Painting is a contagious thing. If you lived in our environment you would probably paint. Our grandchildren think that everyone does." And indeed, an undated group show would include drawings, paintings, and sculpture by Bill's wife, Jeanne, her daughter Teryl, and his three children, Jeremy, Lucy, and Maggie.

Kori

Arthur

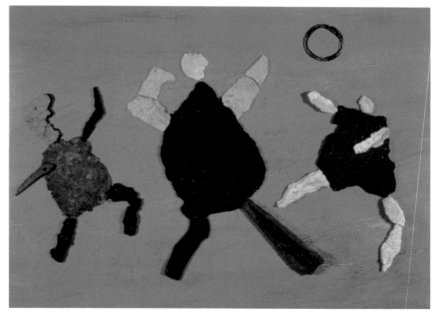

Jeanne

Laura

Joseph

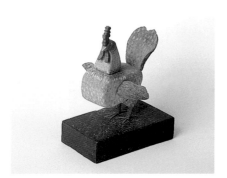

Bill and Jeanne

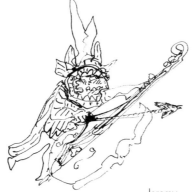

Jeremy

Maggie

Lucy

Teryl

Maggie

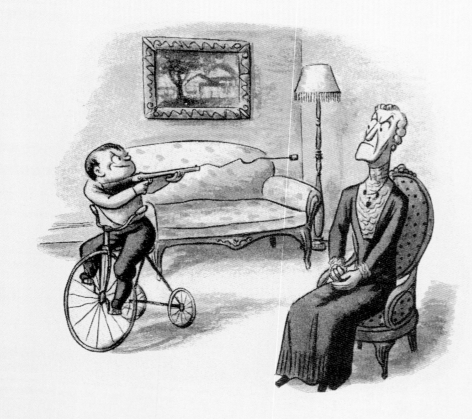

AT THE NEW YORKER

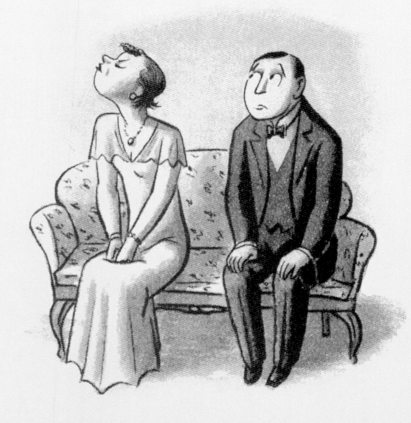

In 1930, when William Steig knocked at *The New Yorker*'s door, some of the most significant comic artists of the twentieth century had already passed through it. Peter Arno and Helen Hokinson had arrived in the magazine's inaugural year, 1925. The work of Otto Soglow, Carl Rose, Alan Dunn, and Mary Petty was appearing

regularly, and George Price had just made his debut. James Thurber, with the publication in 1929 of his collaboration with E. B. White, *Is Sex Necessary?*, had established himself as an artist.

Appearing in *The New Yorker* was the goal of every aspiring cartoonist. It ran the most drawings, paid the highest rates, and had completely transformed the notion of what a cartoon should be. Over the course of the magazine's first five years, the traditional two-line, he-she gag cartoon had evolved into a whole new kind of comic art. Initially the weakest illustrative element in Harold Ross's fledgling publication, cartoons now had a satiric edge and artistic authority. They served as the magazine's graphic center of gravity. Caricature was still featured, but the satiric spreads and the comic-strip-like reportage of the early issues had been elbowed aside by these cheeky newcomers.

When Ross launched *The New Yorker,* the gag cartoon was essentially a short comic anecdote illustrated with a drawing. In its most familiar form, the caption was two, or sometimes three, lines of dialogue. The humor often depended on puns or wordplay, and the drawings tended to be rather literal representations of the situation. Almost all of these cartoons were the result of a collaboration between writers who supplied the idea and the caption, and artists who provided the drawing. The earliest *New Yorker* art meetings consisted essentially of sifting through large haystacks of written gags for a needle or two of wit. Although Ross was fed up with the old cartoon conventions, he didn't know how to move beyond them. At one point, in desperation, he even posted solicitations for gag ideas in the newsrooms of the city's newspapers. As the weekly deadlines seemed to fall

Ambition

Steig's career as a cartoonist started like a shot out of a cannon: His seamless blend of drawing and idea revolutionized the notion of comic art, and his originality was immediately recognized.

one on top of another, Philip Wylie was recruited to create cartoon ideas himself, especially those used by Peter Arno. Despite Ross's and Wylie's best efforts, however, *The New Yorker*'s cartoons at that point were seldom distinguishable from those found in competing journals like *Life* and *Judge.* The notion of a seamless blend of caption and illustration might have remained just a gleam in Ross's eye had it not been for the arrival of a certain young woman. Katharine Angell joined the staff as a reader of fiction in late 1925.

Well-born, well-educated, and remarkably self-assured, Angell brought such intelligence and resource-

fulness to Ross's wildly gyrating enterprise that she was quickly involved in all aspects of the magazine's editorial life. Ross had great confidence in her good taste and sympathetic eye, but there were two other reasons for inviting her to join the Tuesday art meeting. First, since most of the gag ideas were submitted in written form, a literary sensibility was helpful not only in choosing captions but also in reshaping them. Second, given art director Rea Irvin's refusal to deal directly with the artists, the diplomatic skills Angell had developed as an editor made her the natural choice for a liaison between the magazine's art department and the individual artists. The timid Ross, who never got over his belief that artists and writers were prone to unpredictable fits of violence, immediately seized upon this opportunity. As a result, the fiction department assumed the central responsibility for editing the magazine's cartoons. This remained the case from the end of 1925 until Fall of 1939, when the gag writer James Geraghty joined the staff and was appointed its first cartoon editor.

Angell brought the same perfect pitch for dialogue and the same insistence on character that she demanded from *The New Yorker*'s fiction to her editing of cartoons. She also had one indispensable ally: If DNA could be extracted from *The New Yorker*'s cartoons, the biological parents would surely be identified as Katharine Angell and E. B. White, the man she eventually would marry.

White joined the magazine in 1926 and, like most staff members, he wore many hats. He set the tone, urbane and affectionately ironic, of "Talk of the Town," and he was also recruited to help write and rewrite cartoon captions—giving them the same grace and natural rhythm that he imparted to "Talk." He and Angell wed in 1929.

The Whites were dismissive of public theorizing about their work, but the results of their efforts were soon evident: The standards they imposed on the magazine's prose began to shape what the artists produced at the drawing board. Comically highfalutin locutions and ethnic dialect gave way to everyday language. Humor was firmly grounded in character. Although most cartoons were still the result of collaborations, what had previously been a shotgun wedding between idea and drawing now seemed a marriage made in heaven.

When Katharine White reviewed William Steig's first submissions, she must have been startled and gratified to find that they embodied exactly the characteristics she and E. B. White were trying to bring to the magazine's sketches. Steig's bold, literal drawings are notable for their emphasis on character, conveyed not only through facial expressions and body language but also in carefully selected props. His captions have the feel of natural speech, and his ideas reveal a perceptive and sympathetic intelligence. What's more, contrary to the magazine's standard writer-artist collaboration, Steig created his own ideas. (This ideal combination was not achieved by *The New Yorker* cartoonists as a group until the late sixties.)

The New Yorker was not the only magazine to recognize the originality of Steig's talent. After one false start, when he attempted to promote himself as a commercial illustrator, his success as a cartoonist was instant. *Collier's, Life,* and *Judge* began publishing his drawings immediately. In the wake of the Depression, a large

group of humor magazines had sprung up, and these provided a ready market for Steig and other cartoonists of the day. At the end of 1930, his first year "in the business," he had earned more than four thousand dollars. *The New Yorker* was then, as now, the highest-paying market—a fat forty dollars per cartoon. *Life* and *Judge* paid twenty-five, as did *Collier's*. The other magazines, which ranged from *Ha-ha* to *College Humor* to *Hullabaloo*, offered between five and ten dollars for each drawing accepted. In 1931, Steig was well represented in a popular collection entitled *The Stag at Eve.* In 1932, he published his own first collection, *Man About Town.* Within a mere two years he had established himself as one of the most promising cartoonists on the scene, and one of the brightest stars in *The New Yorker*'s firmament.

Steig's earliest pieces are boldly outlined in brush, and given solidity and depth with halftone washes. Occasionally charcoal is used to add texture. The backgrounds are sufficiently detailed to set the scene, but are often perfunctorily rendered: The artist's main interest is his people. Overall, the execution is straightforward, and there is little to suggest the virtuosity of Steig's later work. The most revealing critique of these first drawings is offered by the artist himself, in new versions of his vintage "Small Fry," redrawn for a 1944 collection. The second time around, the backgrounds are simplified, or, in the case of "Now neither of you has it," eliminated. The wash is used more for decoration than dimensionality. Unnecessary props such as the tree on the lefthand side of "Are you sure it's for coffee?" are removed. The specific anatomical features of Steig's early work are more stylized, and the facial expressions less specific, more generic—making the players less

"My youngest is a terror. We can't do a thing with 'im."

Man About Town chronicles the domestic dramas and urbane adventures of Manhattan's hoi polloi and hoity-toity. Several examples from this first collection of Steig's cartoons, published in 1932, are featured on the following pages.

"realistic," but definitely more "real." In general, the effect is lighter, and funnier, and reflects Steig's accelerating shift from the particular to the universal.

During his first years at *The New Yorker,* Steig's subjects often oscillated between the tenement dwellers of his own childhood and the Fifth Avenue "swells"

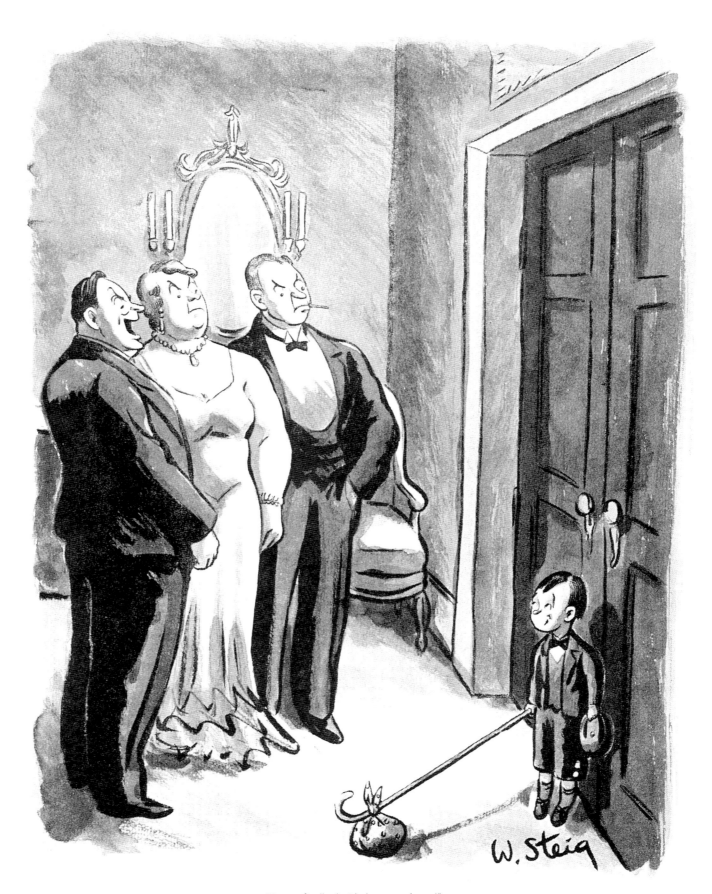

"So you finally decided to come home!"

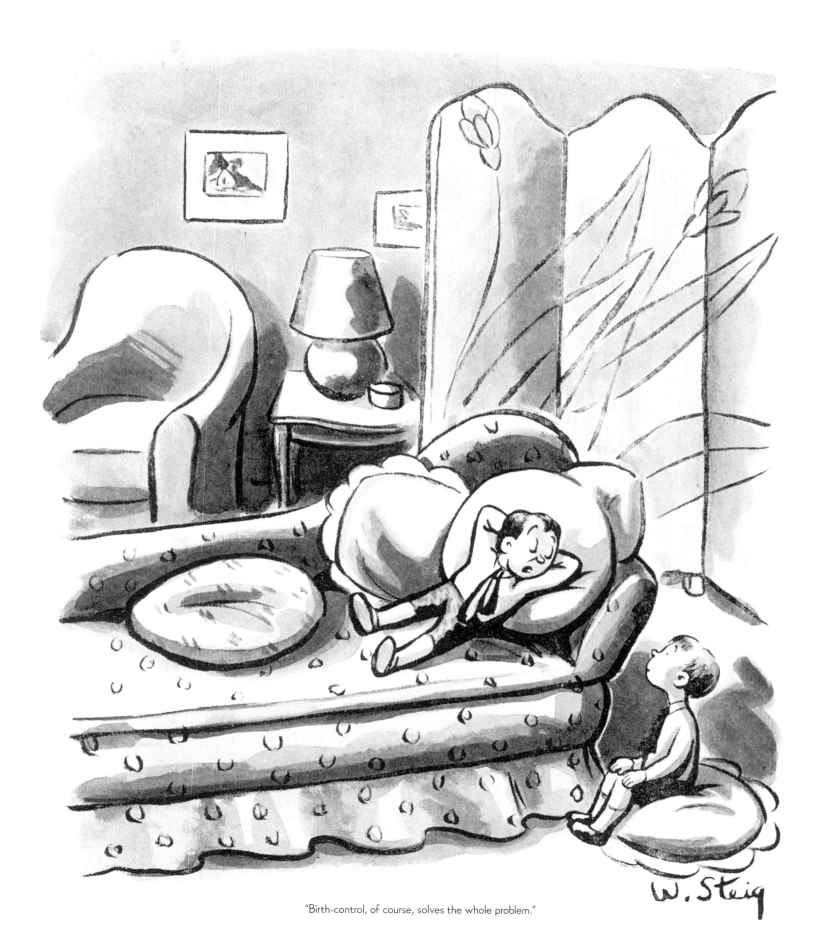

"Birth-control, of course, solves the whole problem."

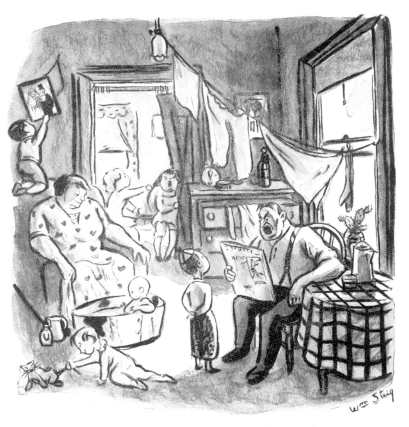

"Don't bother me! I don't know nothing about sex."

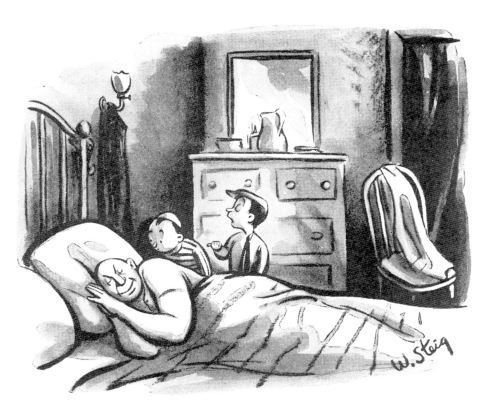

"You can still see the scar."

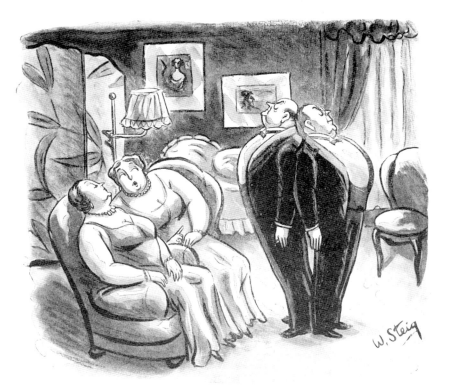

"Yes, but my George has broader shoulders."

"I can trim the pants off you now or any other time."

"Does Mademoiselle wish something else?"

"Do you realize who I am?
I am Morton P. Ipplehart, the only Morton P. Ipplehart in the entire universe!"

"I want you to go right back outside and call **him** a monkey-face."

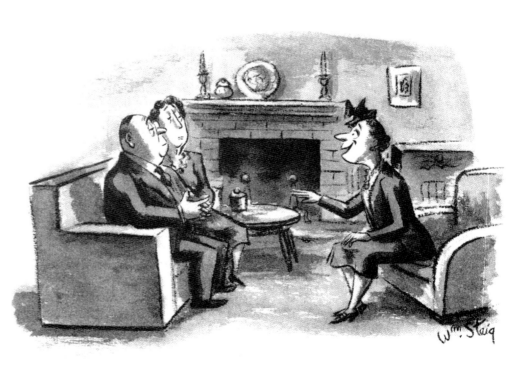

"Don't stand on ceremony. Just throw me out when you get tired of me."

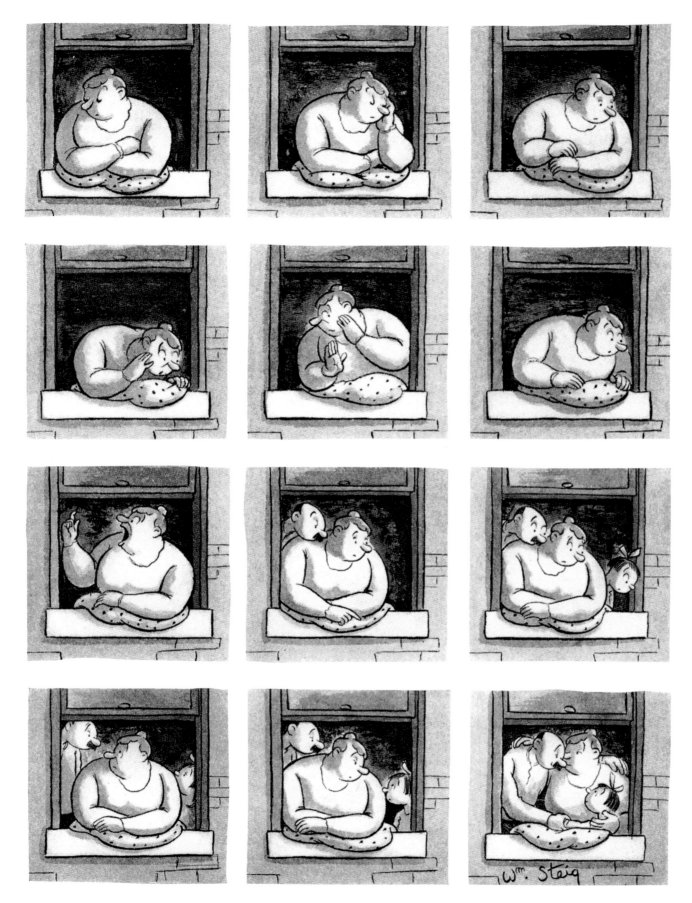

The Accident in the Street

that were favorite targets of the magazine's cartoonists. Although Steig's representations of the upper crust are clearly distinguishable by their tuxedos and ankle-length gowns, the resemblances between the two classes far outweigh the differences. William Steig has never worn a tuxedo in his life, and his drawings suggest as much. If Peter Arno's tycoons and table-hoppers sport tuxedos that appear to have been ironed on, then Steig's fit like pajamas that have shrunk in the wash. (When asked about the prevalence of tuxedos in early *New Yorker* cartoons, Steig replied that the magazine was "hoity-toity.") His rendering of noses presents one curious distinction between the classes: Those of the hoi polloi are shaped like half-eaten pickles, while those of the haute monde are triangularly shaped, like the sandwiches served at a cocktail party. By the time Steig was illustrating spreads such as "Dispensers of Wit" (1935)

and "Holy Wedlock" (1936), his focus had shifted to the middle class, and these issues became moot.

William Steig often describes himself as lacking in assertiveness, but he is well aware of his value, and Katharine White devoted much of her time and energy to smoothing his easily ruffled feathers. Although Steig delivered his drawings and received his okays through Scudder Middleton, White's assistant in the fiction

As Steig evolved as an artist, he increasingly emphasized character over settings. In revised versions of vintage "Small Fry" cartoons, first published in the thirties, Steig eliminated extraneous details and simplified facial expressions.

"Put something on!" (1939)

"Put something on!" (1944)

"Are you sure it's for coffee?" (1932)

"Are you sure it's for coffee?" (1944)

"Now neither of you has it!" (1934)

"Now neither of you has it!" (1944)

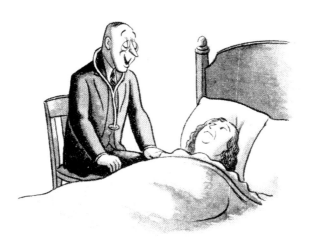

Medical Wag

Pearl-Dropper

Alcoholic

Dead-Pan

DISPENSERS
OF WIT

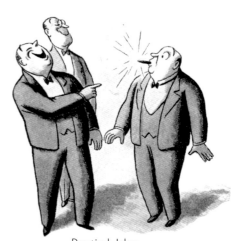

Practical Joker

Punster

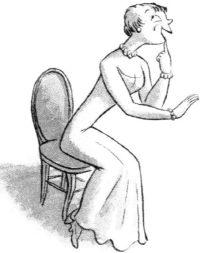

Anecdote-Mutilator

Self-Panicker

department, any bumps in the road were navigated by the editor herself. As the letters on the following pages clearly indicate, the biggest bump, besides the issue of Steig's appearance in competing magazines, was the arrival at *The New Yorker* in 1935 of another young cartoonist, Syd Hoff. Steig felt that Hoff's drawings were poaching on his turf, specifically the subject of the lower classes, and he said so to Katharine White in no uncertain terms. Hoff's broader style reduced the subtleties of Steig's portraits to stereotypes, and Hoff often mocks his subjects—something Steig never does. White's response to Steig's complaints is unknown, but over the next twelve months only two Hoff drawings were published in the magazine. By the time he began to appear again regularly, in 1935, Steig had abandoned the tenements and had trained his lens on the middle class.

Ross's and White's enthusiasm for Steig's work was not shared by the third member of the Tuesday-art-meeting triumvirate, Rea Irvin. His resistance to Steig's charm eventually led Ross and White to reroute the artist's work around the Tuesday meeting. Scudder Middleton delivered Steig's sketches directly to White, who passed them, along with her comments, to Ross; Ross appended *his* comments and passed them back to White, who then dealt directly with Steig. One happy consequence of this peculiar arrangement is that many of Ross's reactions, which normally would have been verbalized at the art meetings, were instead recorded in memos to White. A handful survive in *The New Yorker* archives at the New York Public Library and they offer unique insight into Ross's skill as an editor. His comments make clear that he held the magazine's art to the same standards of accuracy and honesty that he insisted

on elsewhere. It's also evident that Ross was pushing Steig to represent in his drawings a higher social class than he had up to that point (see page 53). Largely ignoring Ross's elaborate instructions, Steig barely

In keeping with his own move from the tenements of the Bronx to a more middle-class existence on the Upper West Side, Steig's focus shifted from the polarities of rich and poor to the mundane concerns of the common man. In such spreads as "Dispensers of Wit," "Holy Wedlock," and "Woe," the artist poked fun at familiar figures: the heavy drinker, the rejected suitor, the bride-to-be.

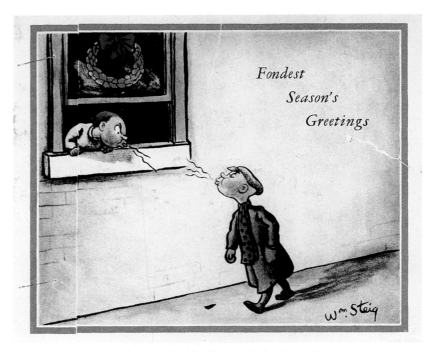

Christmas Card for The New Yorker (1933)
Here's de season's best from a little stiff, / An' a merry Decemmer de Twenny-fif'. An' phooie for Nineteen t'oity-t'ree— / I wish youse a Happy New Year, see?

Creative Agony

Rejection

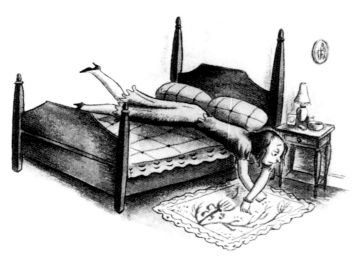

Broken Heart

W O E

Mal de tête

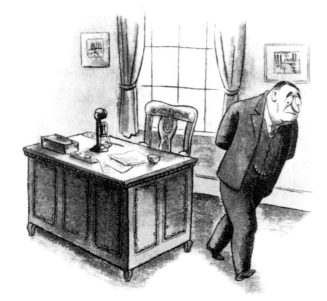

Commercial Anxiety

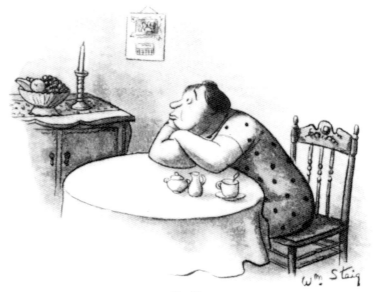

The Blues

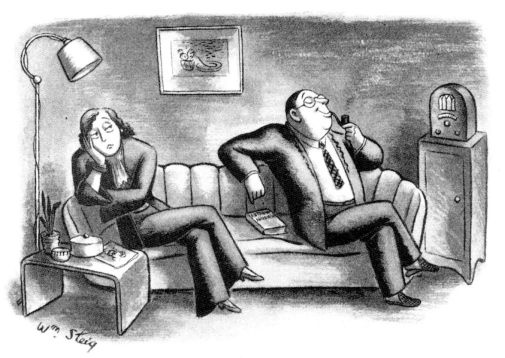

Home-Lover

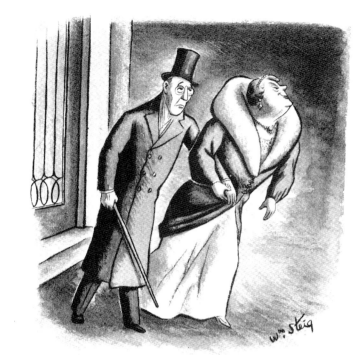

Indefatigable Wife

HOLY WEDLOCK

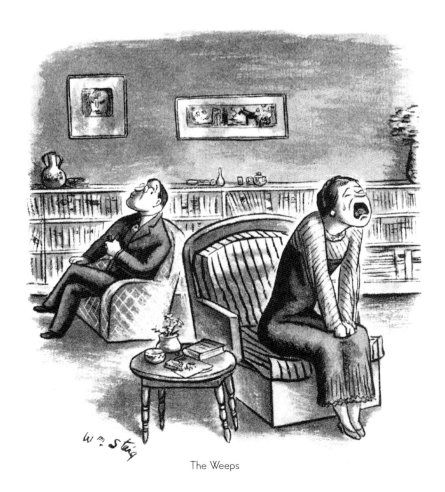

The Weeps

Threatening Paunch

Dear Mrs. White,

. . . Incidentally, in view of the fact that on your account I have turned down various attractive offers, I think you owe it to me to keep vulgar imitations of my work in more obscure corners of the magazine.

Sincerely yours,
William Steig

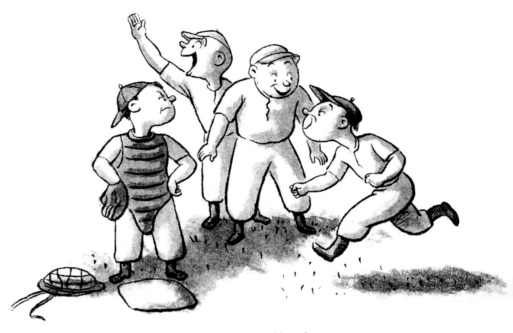

Home Run

Protective of his art, and irritated by *The New Yorker*'s publication of Syd Hoff cartoons, which he considered pale imitations of his own, Steig fired off a series of letters to Katharine Angell White. Representative of a continuous correspondence between the artist and his editor, Steig's notes reveal his sensitivity. White's calm, reassuring replies are indicative of her diplomatic skills.

Dear Mrs. White,

Your puzzlement about my reference to a vulgar imitation of my work really puzzles me. Surely you are not so naive.

I am aware of the fact that *The New Yorker* is a commercial venture and not too deeply engrossed in ethical considerations, but the line should be drawn somewhere. It has been called to my attention hundreds of times, not only by intelligent artists but by average dumb readers, that *The New Yorker* is printing diluted imitations of my drawings. So far I have not said anything. I expected that eventually you would become conscience-stricken.

I don't think it is necessary to explain myself in detail.

Sincerely yours,
William Steig

April 24, 1934

Dear Mr. Steig:

. . . Your postscript about "vulgar imitations of your work" I am somewhat puzzled by and I would like to talk to you about it later.

Sincerely yours,
K. S. White

April 27, 1934

Dear Mr. Steig:

I am anxious to see you and since we haven't heard from you this week I assume you won't be in until Tuesday morning. Could you come in then and talk to me, around eleven o'clock? I think we had better get to the bottom of what is on your mind as we don't want you to be unhappy and we don't want you to make us unhappy. I am sure you will at least be willing to talk to me.

Sincerely yours,
K. S. White

Adamant Umpire

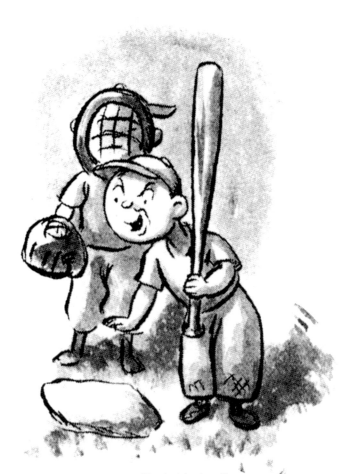

"Put it right there!"

Dear Mrs. White:

During the past year I have accumulated several grievances against *The New Yorker*. I have hesitated mentioning them because arguments are painful to me. However—

1. You object to my using "Small Fry" in advertising and you yourself print them so seldom that they are almost worthless to me as a source of income.

2. I am continually asked to submit more idea drawings, more cover designs, more series ideas — much more material, in fact, than you use. I consider this an unfair demand on my time and effort.

3. Mr. Ross admitted last year that the expert opinion he solicited found Mr. Hoff an imitator. Yet you continue to use him. I can't dictate to you, but my patience has been tried to the point where I am constrained to issue an ultimatum: I have decided that I sha'n't work for you as long as you print Mr. Hoff.

I feel my loyalty to you has not been appreciated.

Sincerely yours,
William Steig

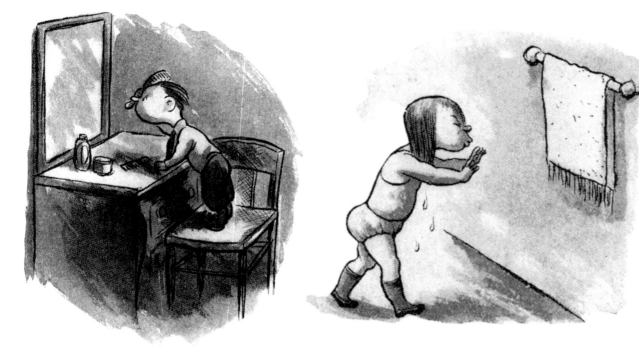

Pompadour

Soap in the eyes

LA TOILETTE

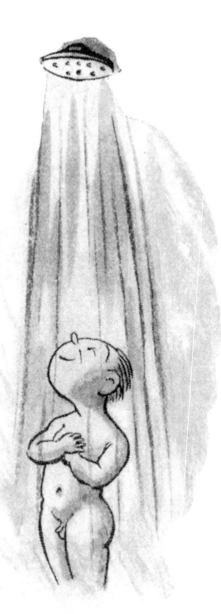

Exhilaration

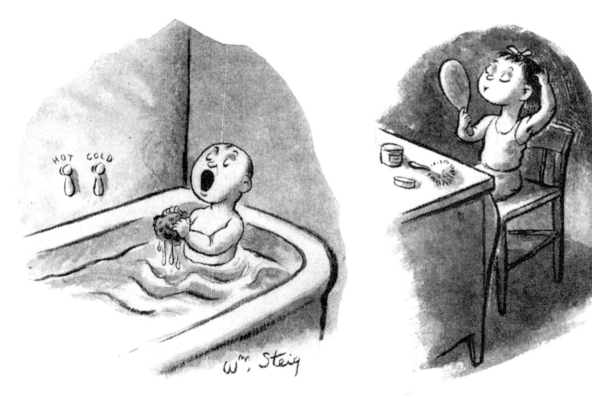

"Kiss me, kiss me again."

The coiffure

altered his originals—only enough to be deemed acceptable for publication.

Ross's supposed naïveté allowed him to suggest that the double entendres of Arno, Galbraith, and others were pranks pulled by unpredictable artists on an unsuspecting editor. Like his reputation as a hayseed, Ross's reputation as a prude was a bit of professional

In a 1934 spread entitled "La Toilette," Steig caused consternation with his depiction of a "Small Fry" boy under the shower. Harold Ross, in a letter to *The New Yorker*'s business manager, referred to "a deep problem" and wondered if he should approach the magazine's owner, Raoul Fleischmann, for permission to publish "this. . . first appearance of complete nakedness . . ." At around the same time, the magazine began featuring Steig's illustrations on its covers.

camouflage. In fact, though famous for his courtly manner with women in public, Ross was known to be a bit of a pouncer in private. But if his actual attitude toward sex was more casual than legend would have it, there was also a wide puritanical streak in his nature. Nudity and any reference to bodily functions embarrassed him. In an anxious note about Steig's drawing of a boy standing still in the shower with a smile on his face, Ross expressed his concern about the child's behavior.

When he finally worked up the courage to ask the artist what the boy was really doing, Steig, deliberately feeding Ross's deepest fears, replied, "Oh, he's just taking a piss." "Just as I thought," Ross sighed.

Although Steig submitted cover ideas to *The New Yorker* from his earliest days as a cartoonist, the magazine did not print any until the middle of 1932. The image, a bold drawing of an anxious child, dressed in period knickers, awaiting his stern father's review of his report card, was sort of an early "Small Fry." Although this was the first cover to be published, it was not the first one Steig had sold. (At *The New Yorker,* this is not untypical.) The first cover Steig actually sold didn't appear until March 1933. The occasion is St. Patrick's Day, and the illustration depicts a woman tinted green by the sunlight as it passes through her green parasol. Both Ross and Katharine White liked the idea as originally submitted, but felt it required more technical polish than Steig possessed at that time. They asked him if he would be willing to sell them the idea to be executed by another illustrator. Steig discussed the suggestion with his parents. His father, always concerned that his headstrong offspring might jeopardize his career, encouraged him to go along. His mother, who had great confidence in her son, insisted that he demand to draw it himself. With characteristic candor, Steig told White that his mother told him he should draw it himself. After consulting with Ross, White agreed.

Steig illustrated many covers in the magazine's first decade, and all of them were essentially color versions of his cartoons. Flipping through them gives no sense of the profound leap forward his talent was making elsewhere.

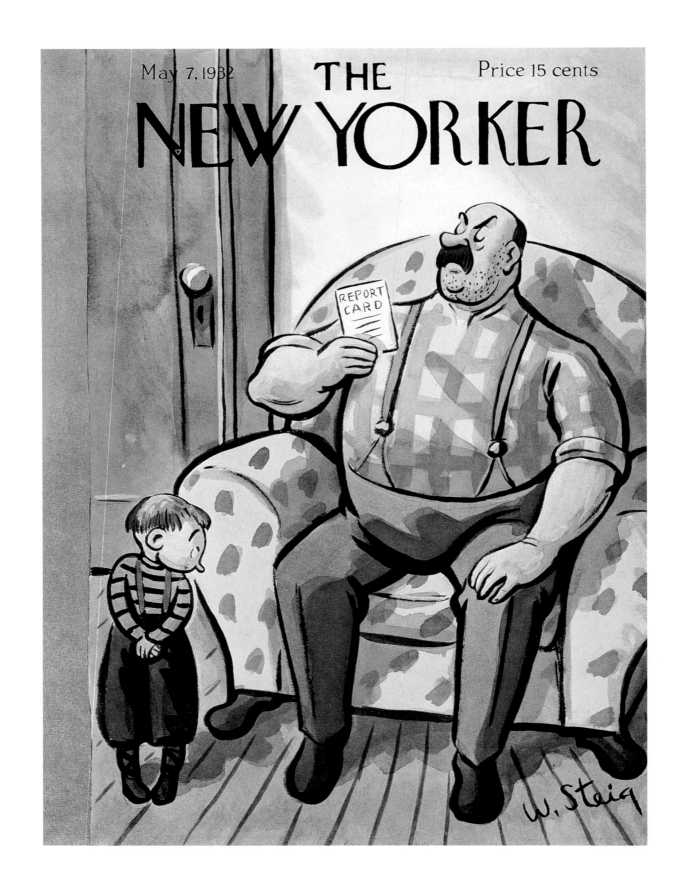

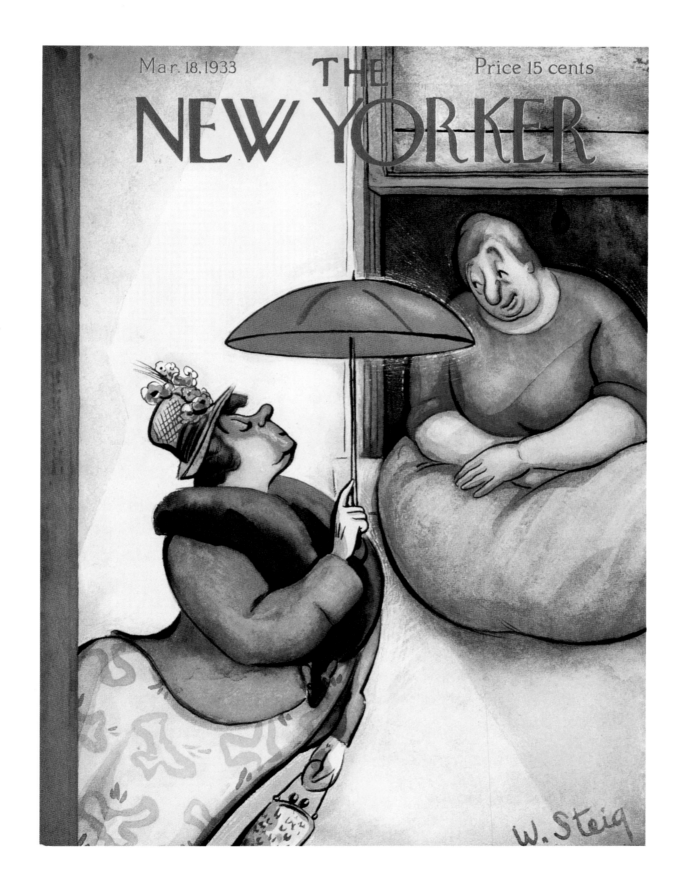

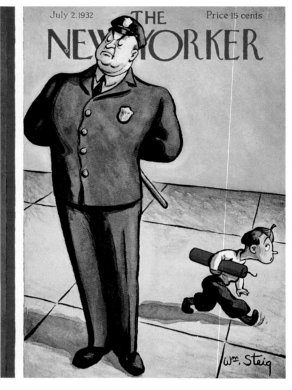

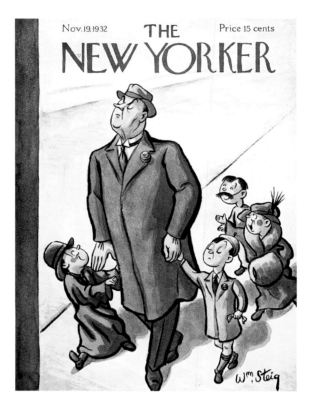

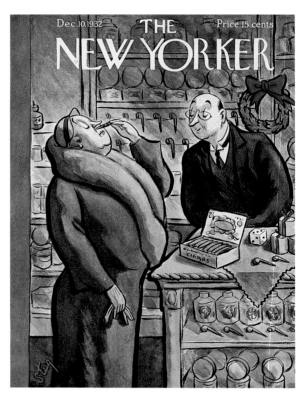

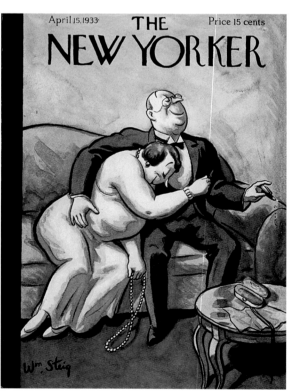

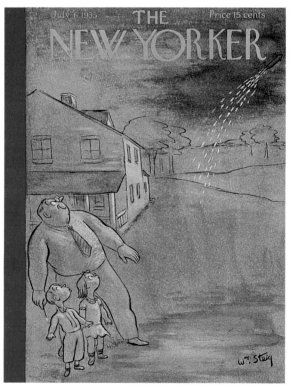

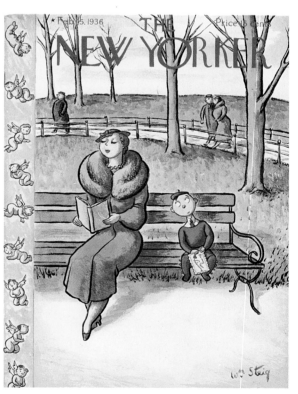

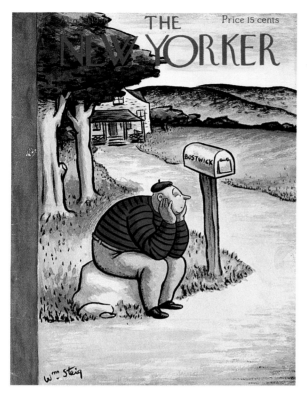

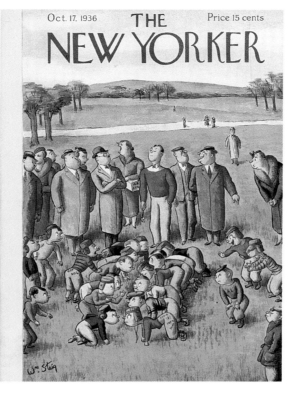

THE NEW YORKER

The New Yorker magazine was the brainchild of a journeyman reporter from the Midwest named Harold Ross. Ross gained his first magazine experience as editor of the armed forces publication *Stars & Stripes* during the First World War. After the war, he settled in Manhattan and continued his magazine career at *Judge* and *Life,* two comic weeklies of the time. While struggling to keep these moribund journals afloat, Ross dreamed of better things. It was his inspired notion to create a new kind of weekly aimed at the well-educated, well-heeled young people responsible for transforming Manhattan into—as a contemporary put it—"Baghdad-by-the-Hudson." The magazine would be witty, sophisticated, and topical. It would be a metropolitan weekly with national appeal. It would "hate bunk" and definitely *not* be for "the little old lady from Dubuque."

As for the magazine being a vehicle for upscale advertisers, Ross's proposal sounded solid enough to convince Raoul Fleischmann, a wealthy member of the Fleischmann (yeast) family, to back him. The family remained the publisher, and principal stockholder, of *The New Yorker* from its first issue, February 12, 1925, until the magazine was sold to S. I. Newhouse in 1985.

Ross realized how crucial the right "look" was to the success of his enterprise, and he was able to secure as his art director one of the best in the business—Rea Irvin. Irvin was a skilled draftsman as well as a designer.

In addition to selecting the magazine's body type, he designed an alphabet for its heading (still used today) and oversaw the layouts. He also drew caricatures, cartoons, spots, and covers, including the Edwardian dandy, later dubbed Eustace Tilley, who appeared on the first cover and continues to run each year on the magazine's anniversary issue. Irvin's drawings established an elegant new look that went a long way toward disguising the rather flat writing in the earliest issues. (One contemporary critic described *The New Yorker* as "the best magazine in the world for people who can't read.")

There was, however, one editorial burden Irvin refused to shoulder. For every drawing purchased, scores were rejected. From 1925 to his retirement in 1951, Irvin insisted that someone else deliver the bad news.

Harold Ross had a reputation of looking as if he'd just fallen off a freight car from Oklahoma, but his notes on Steig's "The Barber Shop" spread indicate that he was not unfamiliar with what today would be called a hairstyle salon. Despite his notoriety as a haberdasher's nightmare, Ross was fastidious about his own personal appearance.

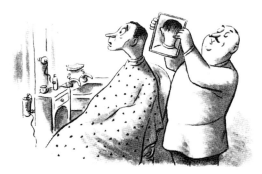

Fait Accompli

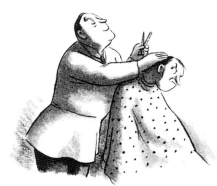

The Heavy Hand

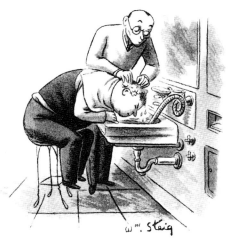

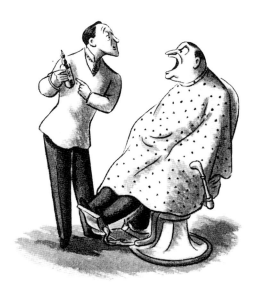

Strong Sales Resistance

THE BARBER SHOP

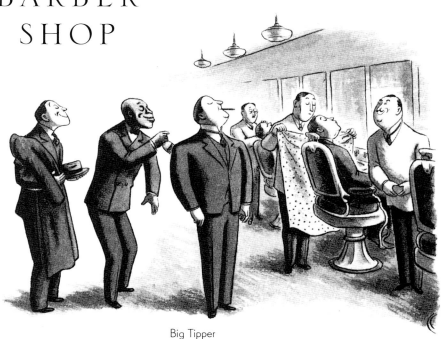

Big Tipper

December 12th, 1935

Mrs. White:

I thought Steig was going to do this on a high-class barber shop and I think he ought to. It doesn't seem to me that he has because of a few items which I will enumerate below:

. . . I think the picture marked #3 ("Big Tipper") is OK but think he has a chance here . . . to make much more of a scene. I always feel that scene is important in these layouts. When I say scene, in this instance, I mean people too . . . The barber's chair doesn't look correct to me at all. It appears to be a dinkey affair and no first class shop has a dinkey little cabinet such as he shows at the right of this picture. If Steig is agreeable I advocate putting in Terminal Shop equipment, built in marble fixtures, bevelled mirrors, pretentious chairs, etc. Also, show more barbers in the background. Terminal has 40 or 50 in some of its places.

The chair in picture #4 ("Strong Sales Resistance") doesn't look right to me. Too dinkey again, and elemental.

The cabinet in picture #5 ("Fait Accompli") again looks like something that would be found in a little Wop place on West 123rd St.

I don't believe in the existence of a little cabinet (like a medicine cabinet) in picture #6 (untitled) except in a bum joint. Moreover the sink is too dinkey and I suspect Steig could make a funnier picture out of it by drawing a more authentic sink . . . When I get a shampoo I sit on something higher than this, allowing my head to project clear over into the center of the bowl, with water squirting down from the top and all around me.

As I said, I think all of the characters in it are fine. It is just the environment that is wrong. I think a high class shop, big scale place is funnier than a little neighborhood shop.

H. W. Ross

VANITY FAIR

The success of *The New Yorker* brought with it new opportunities for the magazine's signature artists. Book publishers vied with one another to bring out collections by Steig, Otto Soglow, Helen Hokinson, and Peter Arno (who, with Philip Wylie's assistance, even created an illustrated novel featuring his improbable Whoops Sisters). Solicitations to draw for advertising were abundant, and Arno's bimbos, Hokinson's matrons, and Soglow's Little King were as likely to be seen hawking beer and cigarettes as cavorting in the pages of the sophisticated *New Yorker*. For most artists, advertising was easy money. For Steig, it was the last resort.

The first resort was finding another home for his work. In 1933, he approached the editors of *Vanity Fair* and offered some material passed over by *The New Yorker*. On Steig's assurance that he was indeed his own man, the magazine purchased several spreads. Before the last of them had run, Frank Crowninshield, Harold Ross's counterpart at *Vanity Fair*, decided to clear his conscience by raising the question of Steig's joint allegiance directly with Ross. Their letters have an Alphonse/Gaston quality, uncharacteristic of either man. Crowninshield disavows any attempt to poach in Ross's preserve and gently suggests that Steig could do something quite different from his *New Yorker* material for *Vanity Fair* —drawings to "illustrate the march of political and national events," for example. He continued, "If we could develop him into a kind of Daumier or Gavarni, we would not feel we were transgressing the bounds of friendship." The results of Crowninshield's ideas can be seen in samples of Steig's work for *Vanity Fair*.

"A Collection of Crow's Feet," published in *Vanity Fair* in 1935, showcases Steig's uncanny ability to capture familiar personality types.

Die-hard

Gossips

Harpy

Patriarch

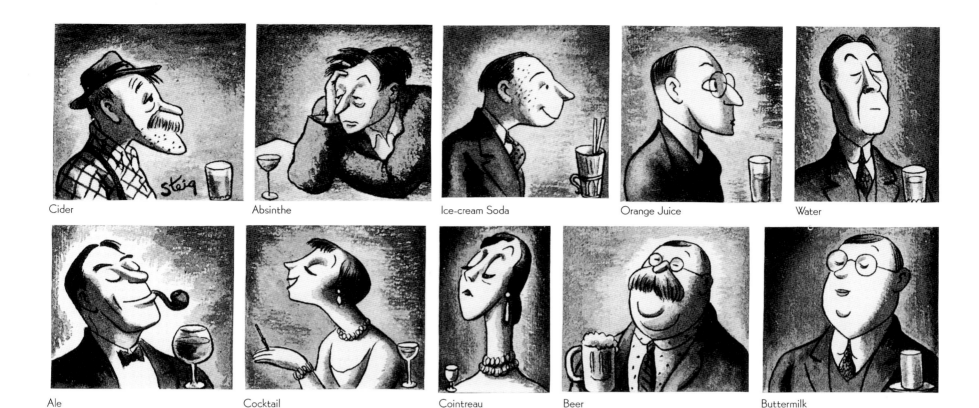

Cider

Absinthe

Ice-cream Soda

Orange Juice

Water

Ale

Cocktail

Cointreau

Beer

Buttermilk

In reply, Ross seems to say that the artist can do whatever he damn well pleases, but he then takes a U-turn and suggests that "we may have some kind of property interest in the boys we develop," and proceeds to dump the question of Steig's fealty to *The New Yorker* in the lap of the magazine's business department—that is, the owner Raoul Fleischmann. The ploy is so embarrassingly transparent that Ross closes his note by writing, "You may regard this answer as ducking the question, which I presume it is."

For Katharine White, who was dealing with Steig himself, not Crowninshield, there was no way to duck the question. Her multiple skills as editor, diplomat, psychologist, and den mother were all put to good use when dealing with the artist.

Any suggestion that Steig's gratitude to *The New Yorker* should inhibit his freedom to work when, where,

Although Frank Crowninshield of *Vanity Fair* envisioned Steig as a modern-day Daumier, the artist preferred his satire on the social side, and was not particularly interested in illustrating political issues. "Drinks and Their Drinkers," "The Crooner," and "The Gamut of Laughter" were all published in 1935.

and for whom he pleased was a red flag to the artist. Though the controversy was never formally resolved, it was finally rendered moot when *Vanity Fair* ceased publication in 1937. (Ironically, *Vanity Fair* was revived in the mid-1980s with the aid of the current editor of *The New Yorker,* Tina Brown.)

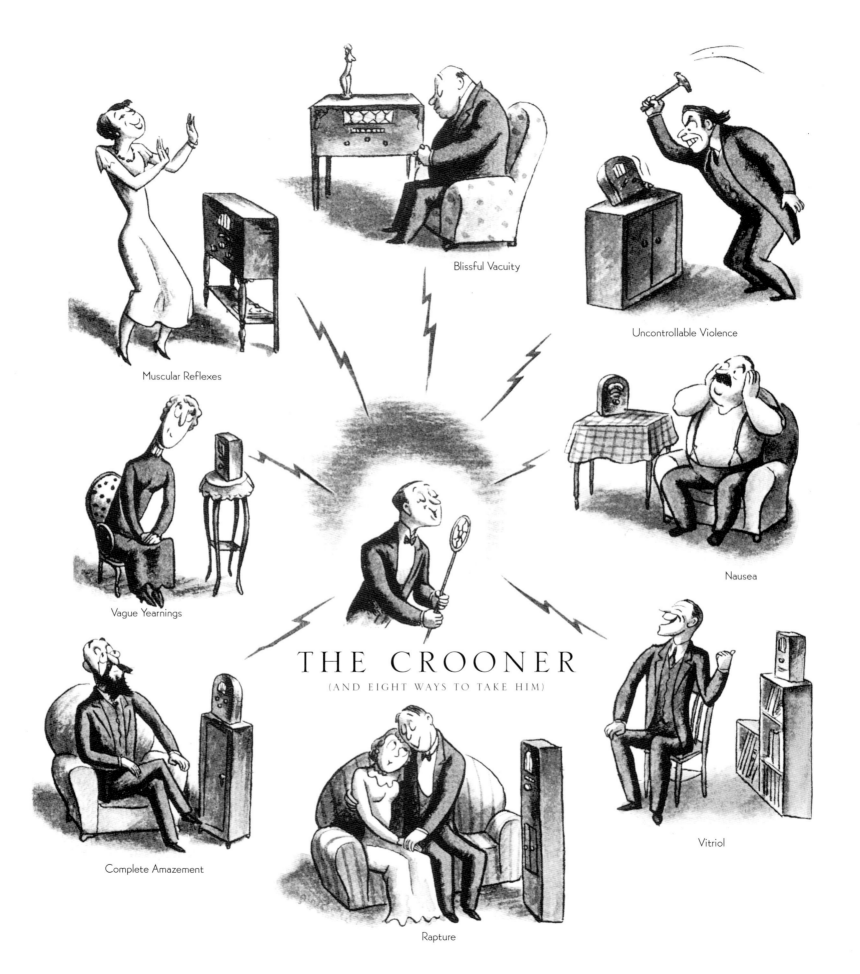

Muscular Reflexes

Blissful Vacuity

Uncontrollable Violence

Vague Yearnings

Nausea

Complete Amazement

Rapture

Vitriol

THE CROONER
(AND EIGHT WAYS TO TAKE HIM)

Contemptuous Snicker

Moronic Joy

Guffaw

Cynical Leer

THE GAMUT OF LAUGHTER

Embarrassed Smirk

Significant Smile

Indulgent Smile

Insincere Smile

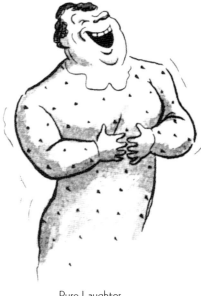

Pure Laughter

"SMALL FRY"

The Dictionary of American Slang defines "small fry" as "an unimportant person or group of persons; persons lacking in influence or prestige, such as unknown entertainers, employees working in union jobs, petty criminals, etc." The more familiar meaning, "children of either sex," is directly attributable to the popularity of William Steig's drawings based on his childhood which began appearing in The New Yorker in 1931. They have proved to be his most popular and durable creations. The cartoons appeared both inside and on the cover of the magazine until the sixties.

Al Capp, the creator of "Li'l Abner," tried, unsuccessfully, to appropriate the name during the Second World War for a strip of his own. Although by 1945 Steig had long since moved on to other subjects, he was still fiercely protective of his early creations. During the Second World War, Al Capp proposed a newspaper comic strip to the United States Treasury Department as part of the bond-selling effort. It was to be a syndicated strip called, of all things, "Small Fry." When Steig heard this he was outraged, and protested to The New Yorker, which in turn protested to the Treasury Department. Eventually a compromise of sorts was reached, and Capp's strip was allowed to appear under the title "Small Change." To secure his franchise on "Small Fry," Steig almost immediately published a short collection in book form. This hardly settled the matter, however, and the state of hostilities between the two artists far outlasted the end of the Second World War.

In the forties, Steig created a series of spreads entitled "Dreams of Glory," in which "cousins" of the "Small Fry" engaged in Mitty-like exploits in defense of their country. Variety reported that the cartoons were serious candidates for a television series to be written by Mel Brooks, though the idea was never realized. Most recently, the "Small Fry" have reappeared in several of Steig's books for children, including Spinky Sulks (1988), Grown-Ups Get to Do All the Driving (1995), and Pete's a Pizza (1998).

Snake Siesta Croquet

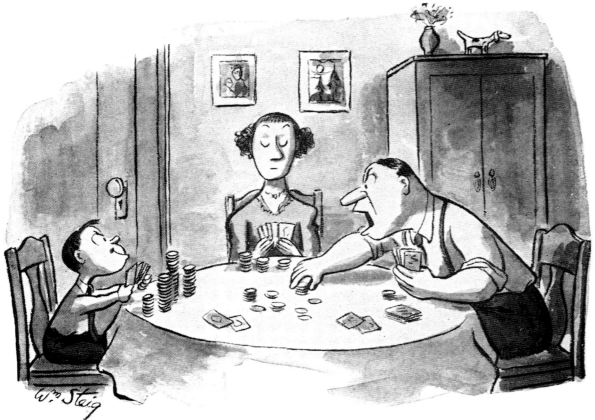

"I call your bluff!"

Danseuse

"This one gives me the most trouble of all."

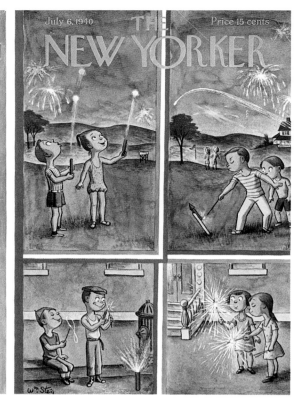

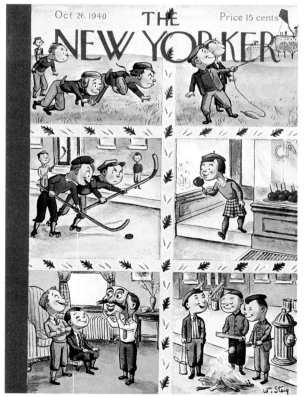

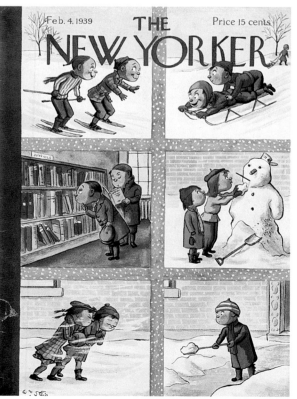

Tattle-Tale

Bully

Peeping Tom

CRIMINAL
TYPES

Pyromaniac

Liar

Sadist

Cheat

The Package from Home

Hesitant Diver

Mosquitoes

SUMMER CAMP

The Canoe Test

Homesickness

Inspection

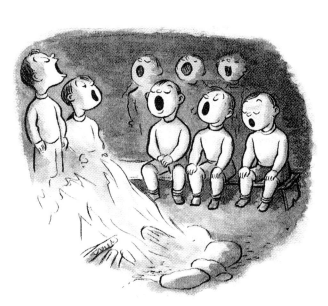

Campfire

SYMBOLIC ART

In 1939, Steig published the first group of what he called his "symbolic drawings." They were collected in a book entitled *About People.* None of them had appeared in *The New Yorker* or elsewhere. The seriousness of this volume was announced in prefatory quotes from Goethe, Whitman, Picasso, Klee, and Blake. Steig has often

named Picasso as his favorite artist, but he's also said that it was primarily Blake, and, to a lesser extent, Klee, who provided the inspiration for these radical new drawings. Blake's poetry had been influential in Steig's artistic development. He'd been trying for some time to go beyond the gag cartoon, to create something that made a more incisive statement about people. In *About People*'s introduction, Steig's brother Arthur explains the artist's aim: "This book contains the first examples of work in a new art form. The newness of this form is not, of course, what makes it important. Its importance rests on the fact that it gives to plastic expression creative and critical values of a high order. These drawings are human in the best modern sense. Their reference is to the psychological integrity of the individual. They are social and creative in the most useful way for our time. They are genuinely critical." The drawings in the slight, remarkable volume, under such headings as "Desperate Man," "Acquisitive Type," and "Difficult Companions," present not stereotypes but archetypes. The book also contains six pages of totally abstract forms labeled with such evocative titles as "The Sly One." These anticipate by more than a decade the graphic experiments of another comic artist of genius, Saul Steinberg.

In the seven years that separate *About People* from Steig's first collection, *Man About Town,* the artist had transformed himself from a gifted cartoonist into a world-class artist. Little in the work familiar to readers of *The New Yorker* hints at what Steig achieves in this slender collection. But even though *About People* startled the lovers of "Small Fry," Steig's art had not changed direction overnight. *About People,* more so than anything that had

Father's Angry Eye

In seven short years, Steig had moved from the cartoons of *Man About Town* to the introspective, analytical archetypes of *About People*. Influenced by such figures as Pablo Picasso and Paul Klee, Steig brought notions of symbolism and abstraction to mainstream audiences.

A Bid for Immortality

Acquisitive Type

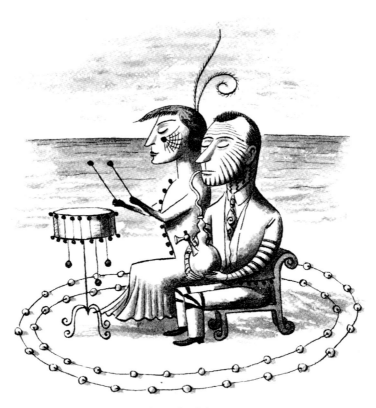

Members of a Culture

Indisputable Possession

The Sly One

Difficult Companion

Desperate Man

appeared in *The New Yorker* up to that point, was simply a more honest expression of William Steig's concerns.

Although *The New Yorker* was Steig's livelihood, it was not his life. His philosophical bent, his profound sense of social justice, and his belief in the redemptive value of art all have deep family roots. These ideals, introduced by his Socialist parents, were stimulated and nourished by the heady intellectual climate of Greenwich Village in the thirties. Steig was very much a part of the bohemian scene, where poetry, philosophy, psychiatry, and sex were discussed around the clock against a backdrop of blues, Bartók, and boogie-woogie. Alfred Kazin, Edmund Wilson, Mary McCarthy, and Edna St. Vincent Millay were among the leading players, and Steig often joined them at parties thrown by

his *New Yorker* colleague Philip Hamburger. Steig also enjoyed friendships that dated back to his days at the National Academy of Art, and with members of the Harlem Renaissance, including Ralph Ellison and Langston Hughes. Stuart Davis, a fellow member of The Downtown Gallery, was a close friend, as was the painter Romare Bearden. In addition to his published work, Steig painted and carved wooden sculptures influenced by African art. (Although his family still possesses a few of these, the bulk of them were purchased back in the thirties by Nelson Rockefeller—for ten dollars each.)

It was at one of these downtown gatherings that Steig met the young woman he married in 1936, Elizabeth Mead. One of four children from an academic family, Liza, as she was called, was a true original— an artist, a musician, and an enchantingly free spirit. During their first encounter, she plucked a handful of small oranges off a decorative plant and arranged them seductively in her hair. Steig was captivated. Mead's family, like Steig's, was full of energy and talent—

Steig was an active member of bustling Greenwich Village bohemia, and his contemporaries included Edmund Wilson, Edna St. Vincent Millay, and Langston Hughes. In addition to drawing, Steig painted, and carved wooden sculptures, many of which were bought by Nelson Rockefeller for ten dollars apiece.

Liza's sister was the anthropologist Margaret Mead. Bill and Liza's daughter, Lucy, born in 1940, remembers her mother as a passionate artist: "She bought art supplies before she bought clothes. She often painted in the kitchen and you had to check to be sure some Prussian blue hadn't splashed into your soup. After my parents divorced in 1946, she taught school and eventually went back and got her M.F.A. She taught at Leslie College, and after she retired she continued to tutor privately. To the end she ate, slept, and lived art."

Although the first examples of Steig's new symbolic work were copyrighted in 1939, an interview published two years earlier in a New York newspaper, the *World-Telegram,* offered tantalizing hints of what was

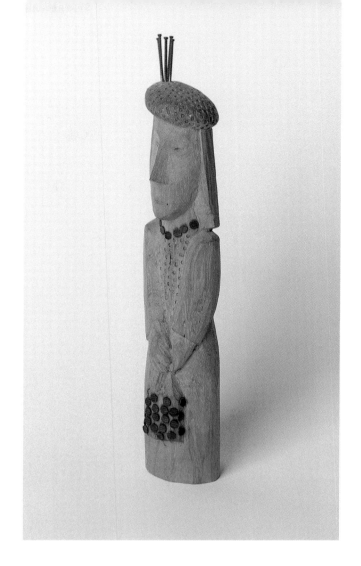

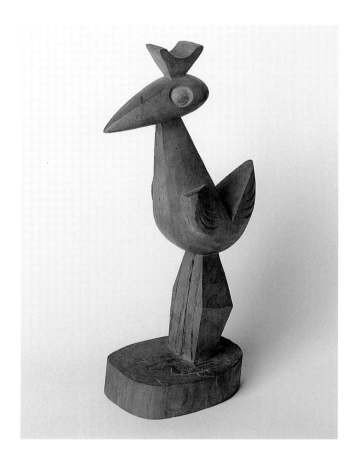

to come. (The author of the piece, coincidentally, went on to become one of *The New Yorker*'s most celebrated reporters, Joseph Mitchell.) Steig also spoke of his recent marriage to Liza, and of the life they were then leading, half in Manhattan and half at a farm they were renting in Gaylordsville, Connecticut. (Steig's carvings were made from wood gathered in the neighboring fields.) Published in February 1937, entitled "A New Cycle in Comic Art," the article begins with a description of Steig's background and early training. It includes some interesting comments, not reproduced elsewhere, about his education as an artist: "The people were nice there [National Academy of Art], but I had

to break away from the training I got. I imagine most cartoonists who went to formal art schools had the same experience. I'm satisfied to do humorous drawings. I think cartooning is a worthy art."

Of particular interest is the artist's analysis of the question of humor: "I think the laughter of a cartoon or a comic strip is pretty well explained by a man named A. M. Ludovici, who wrote a book called *The Secret of Laughter*. A lot of cartoonists believe he's correct. He calls his idea 'The Theory of Superior Adaptation.' The idea is that a thing is funny if it creates in a spectator a feeling of 'superior adaptation,' and that for the moment he is a superior person, certainly superior to the man who's just been hit over the head by the rolling pin. I think that a sense of humor can carry one too far. For example, there are speakers who realize the only way they can put something over is to tell a lot of anecdotes. The audience feels that if a speaker isn't funny, he's no good, and that's bad. I also think that enjoyment of a cartoon involves what Freud calls 'release of psychic tension.' We're all inhibited, and a piece of humor breaks down these inhibitions. Nonsense drawing releases one momentarily from the burden of thinking." The article continues, "Mr. Steig believes that the humorist is an important citizen in periods like this, when the world is afflicted with depression. His comments on the future of cartooning are particularly interesting. He celebrates the death of the he-she gag, and looks forward to a time when cartoons will not depend on captions at all." Cartoons, in other words, very much like the drawings in *About People*.

The publication of *About People* confirmed Steig's reputation as the most significant comic artist of his generation, but it also raised a banner that few artists were equipped to rally around. In fact, the first important successor to *About People* was Steig's next book of symbolic drawings, *The Lonely Ones*, published in 1942. Again, the collection includes nothing from *The New Yorker*. It does include, however, a warm, perceptive, introduction by one of the most important writers at

Steig continued to probe the human psyche in *The Lonely Ones*, published in 1942. His incisive captions, including "People are no damn good" and "I am at one with the universe," found a permanent home in the American lexicon.

the magazine, Wolcott Gibbs. Gibbs had been acting as the fiction department's liaison to the art meeting since the departure of Katharine White. (She had left the magazine and moved to Maine with her husband, E. B. White, in 1939. In spite of the distance, she remained a formidable figure in the art department through her chosen successor, Gus Lobrano. He continued to attend art meetings until after Ross's death in 1951, when William Shawn became editor.) In his introduction Gibbs writes:

In The Lonely Ones, *Mr. Steig offers us a series of impressions of people set off from the rest of the world by certain private obsessions, usually, it seems, by a devotion to some particularly disastrous clichéd thought or behavior. They are not necessarily unhappy. Some of them, in fact, are*

But I can mystify and terrify.

I am at one with the universe.

I can laugh at myself.

I mind my own business.

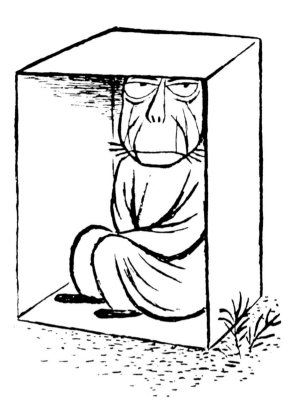

Mother loved me but she died.

People are no damn good.

Public Opinion no longer worries me.

obviously only too well pleased with themselves, and lone-liness or singularity is of course by no means an unhappy state. They are simply not quite like the other boys and girls. His method, not definitely abstract, certainly not literal, seems to me entirely fascinating. In the best of his pictures, or the ones I happen to like best, there is the queer, distorted, but absolutely faithful definition of character available to most of us only in alcohol or a dream when an old friend is apt to appear fantastic, recognizable as the essence of what he is rather than what he looks like. It is Mr. Steig's good fortune, although sometimes it must make him a little nervous, to possess this extra vision while wide awake and, as far as I know, cold sober.

Among the forty-six drawings in *The Lonely Ones*

are several whose captions have entered the language: "Mother loved me but she died," "Public Opinion no longer worries me," and, of course, "People are no damn good." Although the book itself was a financial as well as an artistic success, what—or rather, who—introduced the drawings to a much wider audience was an ambitious huckster named Leonard Zipken. Offering Steig a small seven percent of the net, Zipken licensed the sketches and proceeded to inflict them on the public through every possible medium. *The Lonely Ones* were on ashtrays, cocktail napkins, scarves, and bed linens. Children snuggled down to listen to the Lone Ranger wrapped in sheets that read "I am at one with the universe." Zipken's success can be measured by the

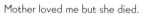

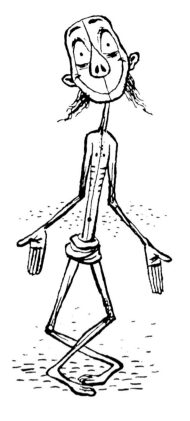

I have nothing to give.

If you are good-natured, people step all over you.

Very few understand my works.

number of baby boomers who have never heard of William Steig but are familiar with these captions. Although Steig made very little money out of these various enterprises, Zipken ended up with a very large estate in Westchester, New York. In a letter to the artist, he proudly refers to it as "the house that Steig built."

Given its groundbreaking nature, *About People* must be considered the more important of the two books, but the drawings in *The Lonely Ones* move beyond the tentativeness of the earlier volume and present the work of a master fully in control of his material. The finicky halftone has disappeared, and the careful brushwork has been replaced by a rhythmically flowing line that occasionally approaches the calligraphic. The ideas are

never required to meet the drawings halfway. *The Lonely Ones* is the perfect blend of inspiration and execution.

In 1942, when *The Lonely Ones* was published, Steig was thirty-five years old. Liza had just given birth to their second child, Jeremy, and their daughter, Lucy, was approaching her second birthday. *The Lonely Ones* confirmed Steig's stature as an artist, and his reputation at *The New Yorker* had resulted in something approaching celebrity status. His parents were enjoying the fruits of their son's success. He now shared his large apartment in Greenwich Village with them, and regularly sent them on exotic vacations. His older brothers were also prospering.

Still, the view from the summit was not equally pleasant in all directions. His beloved brother Arthur

was experiencing the first painful symptoms of what was to be a lifelong battle with depression. The world was at war, and Germany had occupied Poland, the family's homeland. Mankind's brutish nature seemed poised to puncture the fragile shell of civilization. To Steig, the work he produced for *The New Yorker* had begun to seem formulaic and predictable. In the next few years it dropped off. In 1943, he did twelve drawings and one cover. In 1944, he produced no covers and eighteen drawings. In 1945, just one drawing and one cover. And in 1946, the same. He produced nothing for the magazine in 1947. But he did not stop working.

Given the importance that Steig attached to his collections of symbolic drawings, it would be natural to assume that, at this point in his career, his continuing association with *The New Yorker* was primarily to subsidize his more adventurous work. In fact, his relationships with both the editors and his fellow *New Yorker* cartoonists were not only cordial but warm. During Jim Geraghty's years as cartoon editor of the magazine, Steig often joined the Tuesday "Lunch Bunch," which included such regulars as Barney Tobey, Robert Day, Charles Addams, Arthur Getz, Dana Fradon, and Whitney Darrow, Jr. In 1937, Steig and James Thurber competed for a mural assignment in Rockefeller Center. (Steig won.) In the late forties, Steig accepted an invitation from Saul Steinberg to join him in Paris for a guided tour of Europe. Characteristically, Steig is unsure of the dates or the itinerary, but vividly remembers besting Steinberg at the Monte Carlo crap tables.

In 1945, Steig published a remarkable collection of portraits gathered together in an album entitled *Persistent Faces*. Each is rendered with an effortless direct-

ness that suggests a whole new level of skill. Oddly, the high value placed on these drawings by artists and critics is not shared by the artist himself, "the work of an amateur," in his own words. The wildly inaccurate assessment undoubtedly reflects Steig's sour recollection of the mid-forties. His marriage was failing, his *New Yorker* work had fallen off, and he had developed a debilitating case of meningitis.

He consulted a succession of doctors for the meningitis, one of whom recommended a diet of cream and beer, but nothing they prescribed brought relief. A

While the portraits in 1945's *Persistent Faces* seem to evoke the graphic abstraction of Picasso, the dead-on humor of each character study is pure Steig.

chance encounter with an old friend at a party led to a cure, and a new relationship, which Steig describes as the most significant of his life. The friend "radiated serenity and good health." In conversation she revealed she was in therapy with a disciple of the radical psychiatrist Wilhelm Reich.

Reich began his career as a disciple of Sigmund Freud, but, like Rank, Adler, and Jung, he eventually went his own way. Reich believed he had discovered the link between physical and emotional health: a universal energy source he called "orgone." He theorized that any blockage of its flow through the body created neurotic behavior and eventually damaged the organism itself, just as pollution creates destructive consequences in the

Dutiful Son

Investor

Intellectual's Woman

Stooge

Merry Widow

Commercial Visionary

When you and I were young, Maggie.

Darling—Hold me tight.

"To think I hated you at first!"

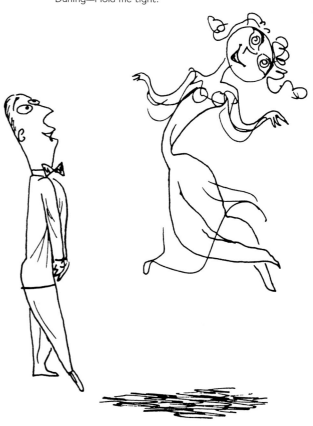

I'm the luckiest man in the world.

atmosphere. To encourage the free flow of orgone, Reich designed a box big enough for a patient to sit in, made from alternating layers of organic and inorganic materials. This was Reich's controversial "orgone accumulator."

German-born Reich had settled in the United States in 1936 and at that time was a prominent figure in clinical psychiatry—his *Character Analysis,* published in Berlin in 1933, is still considered a classic in analytic circles. Steig had briefly skimmed it and other works by Reich, but put them aside. The conversation with his friend persuaded him to look at Reich more closely. He purchased and read a copy of *The Function of the Orgasm.* Greatly impressed, he called Reich himself the next day and the doctor invited the artist in for a

Steig's bittersweet *Till Death Do Us Part*, published in the mid-forties, choreographs the entire cycle of married life, from the elation of love at first sight to the disillusionment of divorce.

consultation. When Steig entered Reich's office, he was surprised to discover a framed copy of one of his drawings from *The Lonely Ones* sitting on Reich's desk.

"I saw him once a week for over ten months. I was recovering from meningitis, and I was also suffering from sulfur poisoning because I'd been treated with a sulfur drug. When I went to see him I thought I was finished. I was about forty years old. Also, my marriage wasn't what it should've been. My idea was that I would get treated by this wonderful doctor and husband and

wife would be reborn, like Adam and Eve. Reich had developed a kind of deep massage to relieve what he called 'body armoring.' He said I was too weak to receive any massages, so we mostly talked. He gave me an orgone box to help build up my strength." Reich managed to save Steig's health, but not his marriage.

Regardless, Steig still considers him the most important figure in his life. "Reich was a great man. He was one of the first to recognize fascism as an 'emotional plague.' Like all great men, he was crucified. The American Psychiatric Association and the AMA hated his ideas and accused him of being a charlatan. In 1956, they charged him with illegally selling unlicensed medical materials (the orgone accumulators). Reich refused to defend his theories in a courtroom and they put him in jail. I visited him there many times and helped to raise money for his legal fees. He died in the Lewisburg, Pennsylvania, penitentiary of a heart attack in 1957."

Reich's only crime, in Steig's view, was being ahead of his time. "He was aware of a universal energy, like Bergson's élan vital or Isaac Newton's ether, and was able to demonstrate its existence. His orgone energy accumulator focuses that energy. It's been demonstrated to shrink tumors. There's one in my studio and I still sit in it every day." Steig believes that Reich's controversial ideas, based on his discovery of orgone as the essential energy force of life, will eventually be vindicated.

To the skeptic, the link between Reich and Steig appears to be more philosophical, even spiritual, than therapeutic. Like Reich, Steig holds strong views on the nature and destiny of mankind, and, like Reich, he believes contemporary society creates a barrier between man and his better nature. Greed, vanity, selfishness,

All Embarrassed

the whole catalog of human weaknesses, were analyzed intuitively by Steig in his drawings long before he met Reich. Reich, however, provided a rich philosophical scaffolding for these ideas, and Steig has remained committed to them ever since. To the outsider, Steig seems more a colleague of Reich's than a disciple. Certainly his next books, *Till Death Do Us Part* (1947) and the brilliant *All Embarrassed* (1948), owe something to the psychiatrist. But if Reich is the godfather, the natural parents are Steig's two previous books.

In 1947, the artist published a new collection that reexamined areas he had first explored in a *New Yorker* spread entitled "Holy Wedlock," published in 1939. *Till Death Do Us Part* is subtitled "Some Ballet Notes on Marriage." From the hesitant shuffle of a courtship dance, captured in a drawing called "The Luckiest Man in the World," to the lockstep of "When you and I were young, Maggie," Steig choreographed the entire cycle of married life. The drawings, unlike the sketches of "Holy Wedlock," are universal, not specific, and the implied score ranges from Scott Joplin to George Gershwin to Richard Wagner. While the drawings are wonderful, the most remarkable thing in the book is an appendix entitled "Theme for an Animated Cartoon." Written like a movie script, "Theme" is a kind of surreal portrait of a marriage—Jiggs and Maggie reworked by Céline and animated by Chuck Jones. (Steig's interest in animation was to be rekindled twenty years later with a proposed

film version of his award-winning children's book, *Sylvester and the Magic Pebble.*

For *All Embarrassed,* Bill's brother Arthur provides a brief and mordant introduction:

We're used to thinking of embarrassment as the temporary discomfiture of a person who is without a face. This book shows that embarrassment is the normal sensation of the human being in our day, that almost all of us feel foolish almost all of the time. The man of the fifth decade of the twentieth century is the embarrassed man. In our elaborately articulated, intricately disorganized society, our primal communal feeling, the cornerstone of our thin brotherhood, is embarrassment. What are its roots? Suspicion of our relationships with one another. For example, the psychiatric fear that

Wisecrack

In his prefatory notes to *All Embarassed,* Arthur Steig explained, "the title of every drawing in this book is EMBARRASSMENT. Other titles are to be regarded as subtitles," and declared that the emotion was man's communal, constant state.

Hero Worship

a suckling baby's ingenuous smile is the leer of incestuous lust gratified. The fact that we are warring for democracy with an army unembarrassedly divided into groups of whites and groups of blacks. Our world, in making embarrassment our constant lot, deadens our feeling for it. This book serves the purpose of renewing our recognition of embarrassment. It is important that we recognize it because arising from equivocations in our relations with one another produces new, and

Only you yourself can be your liberator!

You are afraid of life

You are brutal behind your mask
of sociality and friendliness

more complex, equivocations. The well of the embarrassment illustrated in this book is the interior chaos born in the world of facades. The artist illustrates it with the eye of a poet, satirist, and the eclectic, embarrassed eye of a contemporary.

Although *All Embarrassed* contains some wonderful work, it is a bit of a grab bag. Oddly, some of the sketches seem to anticipate *Persistent Faces,* which was published three years earlier, and the clown drawings have little to do with the basic theme of embarrassment. But if *All Embarrassed* lacked focus, the illustrations Steig provided for Reich's *Listen, Little Man!* (1948) had the intensity of a laser (above). Reich's text is a furious diatribe against mankind's eager collaboration in its own destruction. *Listen, Little Man!* was not originally intended for publication, and, despite Reich's assertions

Steig, an admirer of Wilhelm Reich, considered it an honor to illustrate *Listen, Little Man!,* the psychiatrist's manifesto against mankind's voluntarty self-destruction. But by 1950, in *The Agony in the Kindergarten,* Steig's attention turned to the annihilation of the child.

to the contrary, the exasperated tone often makes the Little Man seem more like the villain than the victim. Steig's drawings, while not groundbreaking, were indispensable to the success of the book. And Steig was delighted to accept the assignment. He describes the invitation to illustrate it as "a gift from Reich."

"Willie!"

In 1950, Steig published his gift to Reich, his gift, in fact, to all of us, the book that many consider his most brilliant, *The Agony in the Kindergarten.* The drawings are truer, funnier, and more excruciating than anything Steig had previously published. Again the art is preceded by a quote from Steig's favorite poet, William Blake: "The Angel that presided o'er my birth / Said, 'Little creature, form'd of Joy & Mirth, / Go love without the help of any Thing on Earth.'"

The initial drawing is of a mother's enraged face as she cries "Willie!" Willie is depicted as a defenseless, gingerbreadlike figure, trapped in the black cage of his mother's screaming mouth. On the following pages, Steig

In each excruciating drawing, *The Agony in the Kindergarten* brought the repressed horrors of childhood back up to the surface.

records how the seeds of melancholia, mayhem, and matricide are planted in the unformed psyches of toddlers:

"Are you a good little boy or a bad little boy?"
"Don't get dirty."
"Little men don't cry."
"God is watching."
"Mommy loves you—when you're nice."
"Don't."

Long before readers reach the last searing drawing, the bitter aptness of Blake's opening lines is apparent: Expect no help in this world, especially from those who brought you into it; life is seduction, life is betrayal; only you can save yourself. These are not exactly the sentiments of the standard Mother's Day card, but they clearly echo the Reich of *Listen, Little Man!.* Like Reich, Steig felt a deep need to help man break free. Twenty years later, he would revisit these themes of independence and courage in his brilliant series of picture books for children, the series which begins with *Roland the Minstrel Pig* (1968).

Mommy loves you—when you're nice.

Don't get dirty.

Are you a good little boy
or a bad little boy?

God is watching.

Little men don't cry.

How would you like a good crack on the head?

Don't.

You're just imagining things, dear.

God didn't put that there to play with.

How do you like your new baby brother?

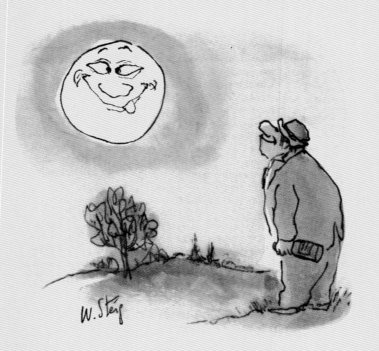

THE YEARS
WITH SHAWN

In 1951, Harold Ross, the founder and editor of *The New Yorker,* died. During the illness preceding his death, Ross had shifted most of his editorial responsibilities to his managing editor, William Shawn. In the eyes of most *New Yorker* staff members, even including the publisher himself, Raoul Fleischmann, this effectively anointed Shawn

as Ross's successor. His ascension, however, was by no means automatic. The most formidable contender was Gus Lobrano, who had assumed control of the fiction department after the retirement of Katharine White in 1937. Lobrano was highly regarded by the entire staff, and he was the preferred choice of some of its most influential members. Gifted as both a writer and an editor, he was, unlike the reclusive Shawn, outgoing and accessible. The closet drama was quietly resolved on January 21, 1952, when a note was posted on the bulletin board which read "William Shawn has accepted the position of editor of *The New Yorker,* effective today."

Under Ross *The New Yorker* had become famous for its art. Almost everyone could quote a favorite *New Yorker* cartoon, and tear sheets of the covers had become the decoration of choice in bathrooms from Burbank to Bar Harbor. Shawn had begun his career at the magazine as a reporter. He had headed up *The New Yorker*'s fabled fact-checking department, and it was generally agreed that, as a fact editor, he was peerless. Shawn was widely, and justly, credited with establishing *The New Yorker*'s reputation as a showcase for the best in journalism. On the other hand, he'd had no experience with the magazine's art. James Geraghty, who had been dealing with the artists since 1939, revealed in his unpublished memoirs his belief that Shawn would turn responsibility for the art entirely over to him. He was astonished when he realized the degree to which Shawn intended to involve himself in the selection and editing of the magazine's art. In hindsight, it's clear that Shawn had from his early days at the magazine been a quiet but passionate observer of the magazine's art. After assuming the editorship, he moved quickly to take complete control of it. Within his first month on the job, he'd "retired" Rea Irvin and "excused" Gus Lobrano from the art meetings. He reassigned Daise Terry, who had been recording secretary at the art meetings, to the rights and permissions department. He even fired the "art boy," a junior member of the staff who held up the finished drawings for examination at each meeting. From that day in 1951 until the arrival of Tina Brown in 1992, the art meeting consisted of only two people—the art editor and the editor in chief.

By the early fifties, Steig considered the continuing popularity of his "Small Fry" a mixed blessing, concerned that they overshadowed what he considered to be his more important symbolic work. But in 1953, he agreed to the publication of *Dreams of Glory and Other Drawings*, a retrospective of "Small Fry" cartoons, specifically those related to the war years.

Shawn's impact on the magazine's art was gradual but profound. He was responsible for eventually phasing out gag writers, thus encouraging a whole new generation of cartoonists, including Ed Koren, William Hamilton, Donald Reilly, Warren Miller, Charles Barsotti, and George Booth, who illustrated their own ideas. Under his editorial hand, *The New Yorker* evolved from a humorous weekly which featured solid journalism to a literary weekly of high-minded

Movie Star

of the Second World War, he revived them in "Dreams of Glory," and again later in a series of seasonal covers. In the fifties, he once more built covers around them, and he finally allowed a representative collection, entitled *Dreams of Glory and Other Drawings,* to be printed in 1953. That Steig had allowed more than twenty years to pass before reprinting these pieces was primarily due to his reluctance to keep his early drawings in print. (He personally destroyed almost all of the original work he'd produced from 1930 to 1940.) In *Dreams of Glory,* Steig took the opportunity to redo many of these drawings and to restore the captions as he had originally written them (some had been changed by *The New Yorker* staff).

Steig takes what he does seriously, as he makes clear in a remarkable introduction to *Dreams of Glory.* Along with some deep thoughts on the state of the universe, he reflects, more mundanely, on the peculiar business of creating comic art:

journalism which was leavened with humor. As the magazine changed under Shawn, it provided a more congenial environment for the reflective drawings of William Steig and his new colleague Saul Steinberg—drawings that would have seemed out of place in the determinedly casual *New Yorker* of Harold Ross. Of course, none of the editorial changes had any immediate impact on Steig's relationship with the magazine. As usual, he continued to go his own way.

At this point in his career, Steig found the continuing popularity of his "Small Fry" a mixed blessing. The public's focus on these early sketches overshadowed what he considered to be his more important work—*The Agony in the Kindergarten,* for example. On the other hand, "Small Fry" were money in the bank. During the years

Breaking the Bank at Monte Carlo

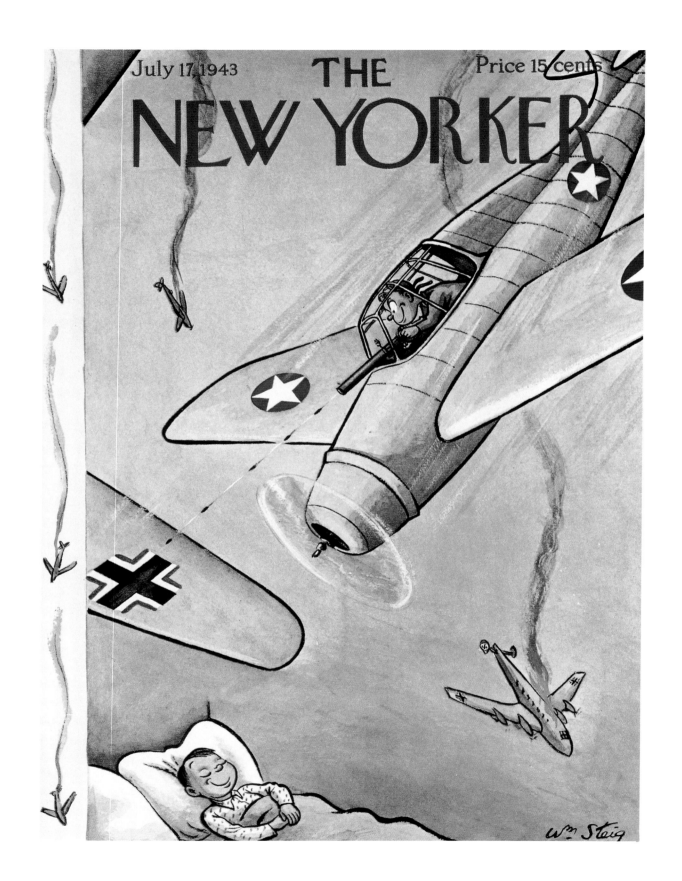

National Hero

The Boy who brought Peace to the World

I find it impossible to imagine man creating humor for his own amusement—or for his own good, as a man paints or composes music to realize his affinity with God. Humor, more than other forms of expression, calls for a communicant, and it is natural for the communicant to want to know from whom he is hearing. . . .

I believe that people are basically good and beautiful, and that neurosis is the biggest obstacle to peace and happiness. . . . In justification of this particular book I think I can say that even in these light drawings I am essentially identified with nature's point of view, as against civilization's, and sometimes succeed in pointing out the ridiculousness of conditioned human behavior.

Why do I concentrate my attention on kids? As the Balinese say, children walk with God—that is, from the point of view of a well-civilized adult they are touched in the head and therefore fascinating. . . .

The dreams of glory, if I think about it, are a kid's almost futile dream of living more than the usual dull routine—his only way of imagining heroic action in a world that affords little opportunity and that is so poor in good examples.

Steig concludes by saying, "This is quite a philosophical preface for a light book. I have wrestled with myself in front of you, and I feel better now about this publication. I want you to know that I mean you well and that I work for you as well as for myself."

While proceeding rather gingerly to introduce his more personal drawings into *The New Yorker*, Steig was breaking new ground with his spreads, and occasionally with his covers. The September 26, 1959, issue contained a six-page spread entitled, "A la Recherche

du Temps Perdu." The madeleine that had evoked these childhood recollections was, perhaps, the birth of his second daughter, Maggie, the previous year. Avoiding the fuzzy haze of nostalgia, the drawings seem less the memories of an adult than the immediate transcriptions of events by a child. This same approach was used again in the 1964 spread "Mythology," and in "American Beginnings," which ran in 1976.

In such *New Yorker* spreads as "A La Recherche du Temps Perdu"—and, later, "Greek Mythology," "Fairy Tales," "Scenes from Genesis and Exodus," and "American Beginnings"— Steig introduced a style utterly lacking in pretense or affectation—as if scribbled by one of his own "kids" from . . . *the Kindergarten.*

Danny was always clowning at the table.

Pa and Ma had European friends.

Pa used to bang on the radiator for more heat.

Mrs. Dixon loved cats.

Pa said that Mr. Hoffman was a genius.

GREEK MYTHOLOGY

Persephone is carried off to the underworld.

Pygmalion falls in love.

Hercules goes mad.

FAIRY TALES

The Beast proposes to Beauty.

The Frog Prince calls on the Princess.

SCENES FROM GENESIS AND EXODUS

And God saw that it was good.

And they were both naked, the man and his wife, and were not ashamed.

AMERICAN BEGINNINGS

The Landing of the Pilgrims on Plymouth Rock

Henry Hudson on the River That Will Bear His Name

Steig's covers, which finally abandoned "Small Fry" after the fifties, were also receiving a lot of attention, not all of it flattering. For the Christmas issue of December 22, 1962, he produced a drawing of a father reading the nativity story to his daughter. Father and daughter are drawn in a relatively straightforward manner and printed in black and white. The nativity scene is drawn in the manner of Steig's "Proust" spread and colored in the bold palette of a child's crayon box. For many *New Yorker* readers, this gentle evocation of the holiday was, to quote one letter to the editor, "an insult to every Christian." Another reader characterized it as offensive, and a third wrote, "Mr. Steig is to be pitied, and you should be ashamed. God help you." It's sobering to report that, for the so-called sophisticated readers of *The New Yorker,* anything other than a traditional rendering of the nativity scene would be considered blasphemous. At least one reader, however, responded to the spirit and not the style of Steig's drawing. "Steig's cover," he wrote, "is a work of real genius. It has the best of Christmas in it: the sense of wonder in the story that has moved men's hearts through the ages."

From the fifties through the seventies, Steig's *New Yorker* work moved on two tracks: that of traditional captioned cartoons, which Steig felt were his bread and butter, and gradually, as if testing the waters, a sprinkling of his more personal work. Early examples of these were collected in a 1963 book called *Continuous Performance.* The range of work in this small and undervalued volume is revealing. There are series of cartoonlike sketches, collected under such headings as "At the Door," and character studies, such as "Man and Woman" and "The Unpopular One." "Some Notes on Affectation" and

"At the Door"

"Stargazer" seem to hark back to early works such as *About People.* The brilliant "A la Recherche du Temps Perdu," a harbinger of later *New Yorker* spreads such as "King Arthur" and even some of Steig's books for children, for example, *Rotten Island* (1984), is included. The collection concludes with "Punch and Judy: Their Later Years," yet another hilarious chapter in Steig's continuing chronicle of the war between men and women.

Nineteen seventy-three was an important year for William Steig. He married his fourth wife, Jeanne, a writer and artist, beginning a partnership he has described as "the richest and happiest" of his life. Nineteen seventy-three was also the year James Geraghty, who had been Steig's editor since joining *The New Yorker* staff in 1939, retired. William Steig is a man of high ideals, ones that often brought him into conflict with those involved in the less exalted business of producing a weekly magazine. He and Geraghty had

"Stargazer and Five Other Marvels"

"The Unpopular One and Others"

Initiate Sage

"Some Notes on Affectation"

weathered a few storms, but there was great respect—affection even—on both sides. Steig remembers Geraghty as a sensitive editor with a very quick wit: "One day, somebody mentioned a neighbor who had died while mowing his lawn, and Geraghty said, 'He who lives by the sward dies by the sward.' "

"Man and Woman"

Geraghty's opinion of Steig is well expressed in a letter sent just before the editor retired (the ordeal he refers to is that of selecting cartoons for the magazine's fiftieth anniversary album):

November 14, 1973

Dear Bill,
Recently I have had occasion to examine thousands of cartoons that have appeared in *The New Yorker*.
One of the impressions remaining to me from this ordeal is the conviction that it would probably not be too extravagant to surmise that in all the history of graphic expression your genius is unsurpassed; for sensitivity and comic perception of the human plight, for loveliness of line, for constant renewal, constant freshness.
(The phrase "graphic expression" is too limiting, but I can't think of another at the moment.)

My best, Jim

Continuous Performance, published in 1963, featured an assortment of Steig's more personal work, organized around such themes as "At the Door," "The Unpopular One," and "Punch and Judy: Their Later Years." At the same time, Steig continued to produce covers and traditional captioned cartoons for *The New Yorker*.

"Punch and Judy: Their Later Years"

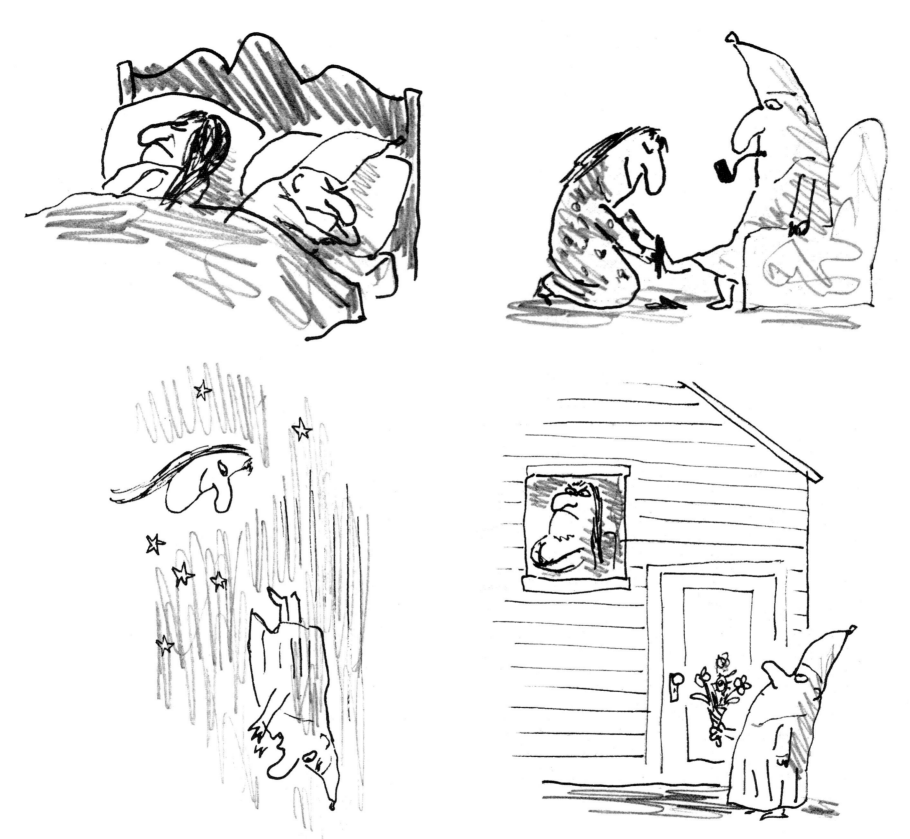

"Punch and Judy: Their Later Years"

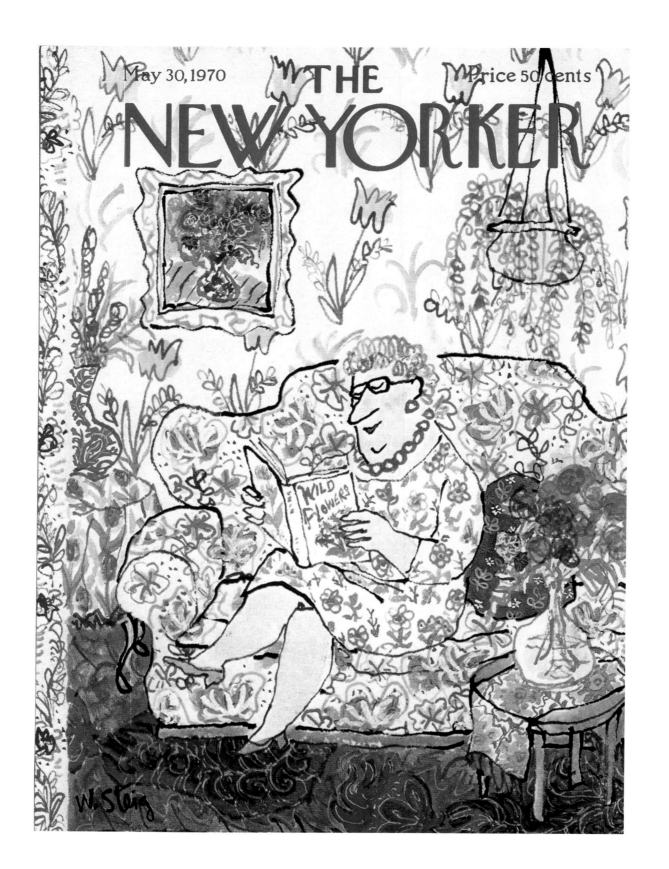

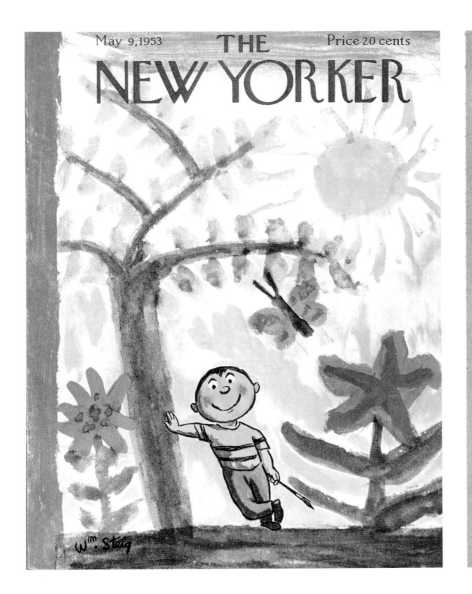

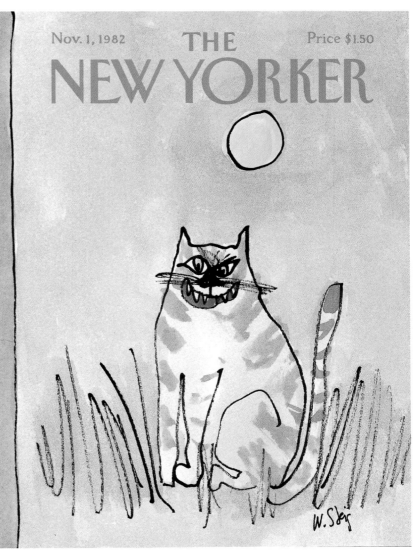

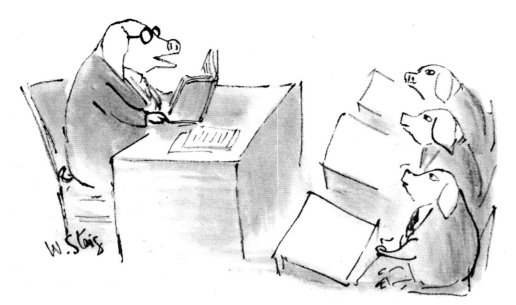

"Allia-Gay est omnis ivisa-day in artes-pay es-tray."

"O to be young and a jackass again!"

"I said, 'Get off'!"

"Now, look here! I'm poor and you're rich!"

"You despise me, don't you?"

"A little respect, if you don't mind!"

"No! Not even one penny!"

Ruminating

W. Steig

Birthday

W. Steig

A Self in Love

W. Steig

The Napper Wakes

W. Steig

Ingrate

Tough Hombre

GENDER WARS

The peculiar relationship between men and women has preoccupied humankind ever since we dropped out of the trees. It is the fabric from which the earliest folktales are woven, and has been responsible for box office hits from *Lysistrata* to *L.A. Confidential.* It is the ace up the sleeve of every humorist, the meal ticket of cartoonists since Rowlandson and Daumier.

The he-she gag cartoon was standard fare when *The New Yorker* debuted in 1925. From that day to the present, *The New Yorker*'s artists have examined the subject with a range and subtlety to rival Stendhal: from Peter Arno's lecherous tycoons and pneumatic blondes to Helen Hokinson's corseted club women; from Charles Saxon's desperate suburbanites to William Hamilton's predatory WASPs.

James Thurber's *War Between Men and Women* (1932) is a classic of the genre. When it comes to putting the sexes on the couch, Thurber's only rival is William Steig. Thurber's Midwestern upbringing had little in common with Steig's childhood in the Bronx, but both artists drew heavily on their families in their work. Although Steig resists drawing parallels between his art and his family, the stormy relationship between his parents is a persistent theme in his work. But the volatile couples portrayed in *Till Death Do Us Part* (1947) and "Punch and Judy: Their Later Years" (1963) represent only a few degrees of Steig's compass. From a child's first crush, through the rituals of courtship, to the final parting, whether bitter or sweet, Steig has illustrated every aspect of this endless and perplexing struggle. The intelligence and empathy he brings to the task are beyond the range of any of his contemporaries, and his erotic drawings can comfortably hang beside those of his mentor, Picasso.

Speechless suitors, childhood sweethearts, prim spinsters. An artist and his muse, an elusive butterfly of a bachelor, Punch and Judy with rolling pins at the ready: Every aspect of the battle of the sexes has been explored with exquisite empathy in the work of William Steig.

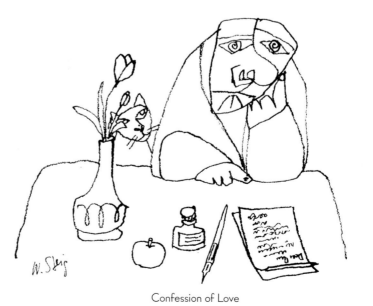

Confession of Love

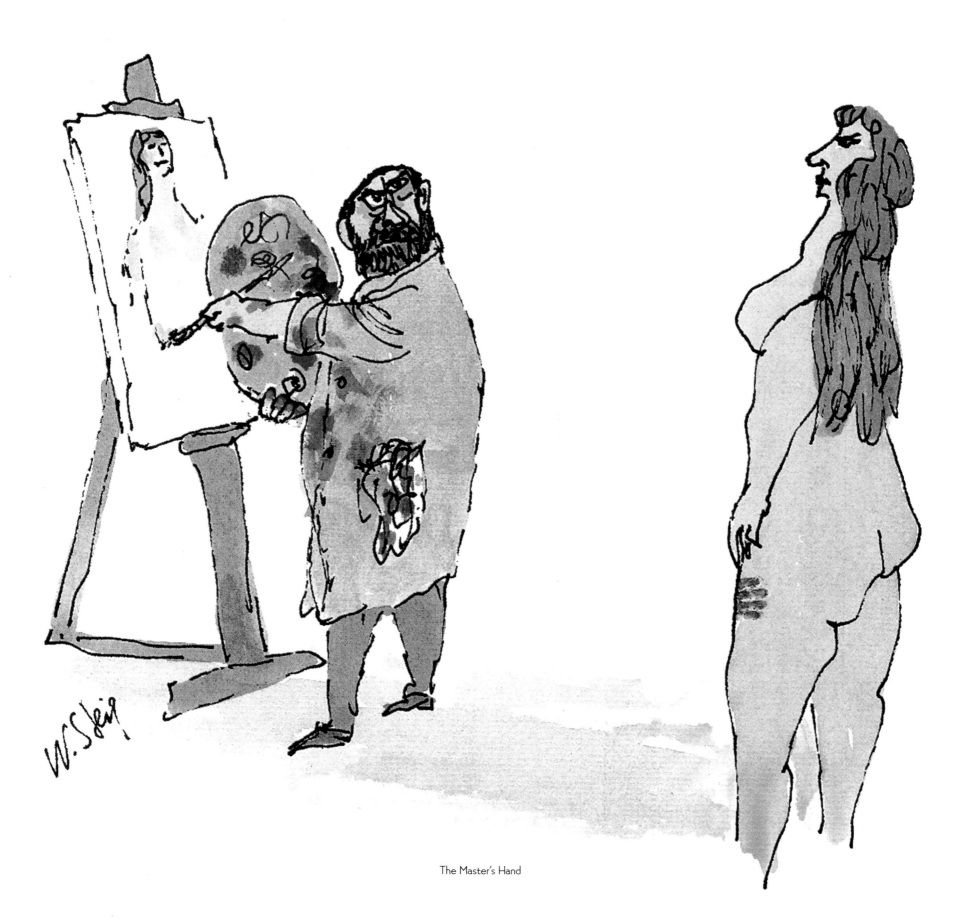

The Master's Hand

"'Depressed?' Why should I be depressed?"

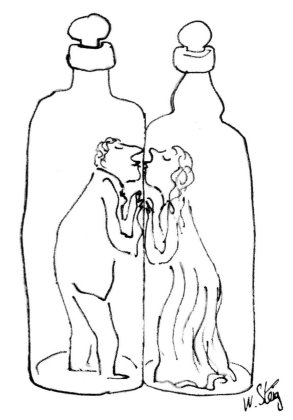

Déjeuner sur l'Herbe

"I made it the way your mother makes it"

Made for Each Other

"Relent!"

"It always rains on our anniversary"

July 28, 1975

THE

Price 60 cents

NEW YORKER

Just a Silly Quarrel

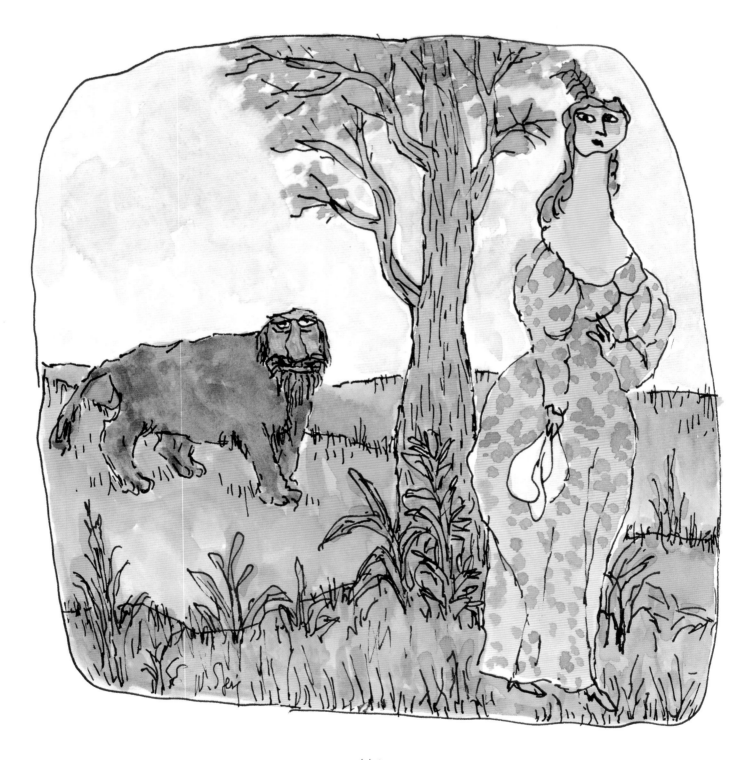

Admirer

THE ARTIST'S HAND

When James Geraghty retired in 1973, William Shawn invited me to succeed him as art editor of *The New Yorker.* I was stunned. Geraghty had been a superb editor. Having started himself as a gag man, he had been a resourceful steward of the first generation of *New Yorker* artists, and after the Second World War had helped Ross

recruit a whole new crop of brilliant young cartoonists. These were my contemporaries—Don Reilly, George Booth, Warren Miller, Ed Koren, and Charles Barsotti. The prospect of facing them from the other side of the editorial desk was sufficient cause for trepidation, but the notion of editing legends like George Price, Charles Addams, Saul Steinberg, Whitney Darrow, Jr., and, of course, William Steig, was paralyzing. With Shawn's assurance that I would merely be "auditioning" for the job, I finally accepted. It's largely due to the generosity of the artists themselves that this "audition" continued for almost twenty-five years. (When I retired, in 1997, I still had never signed a contract.)

Many *New Yorker* readers may imagine, incorrectly, that the cartoons fly directly from the artist's brow onto the printed page. The truth is less mysterious but more interesting. The process begins at the artist's drawing board, where he or she prepares the weekly batch of "roughs." These are preliminary sketches, usually too rough to reproduce, but detailed enough to suggest the characters and the setting. The proposed caption is either hand-lettered or typed below the drawing. Even though most artists are easily identified by their styles, it's customary to write the artist's name and address on the back of each sketch. The size and technique of these preliminary drawings vary widely. Charles Addams almost always worked with charcoal pencil, sketching loosely on large—that is, fourteen by eighteen inch—transparent sheets of visualizer paper. At the other end of the scale, Charles Barsotti produces carefully executed, finished drawings, rendered in India ink, on pieces of heavy bond paper trimmed slightly larger than index cards. Though sketched in pencil,

George Price's roughs were nearly identical, down to the occasionally split pen line, to his finishes. Frank Modell's drawings often arrived crumpled and coffee-stained, as if they'd been dashed off at the last moment at the counter of a nearby luncheonette (it often turned out they had).

The average batch runs anywhere from ten to twenty drawings, although the phenomenal James Stevenson regularly produced forty or more sketches a week. Winnowing this great pile of material down to a stack small enough to wrestle through the door into the art meeting is part of the art editor's job. Working with the editor, those in the meeting reduce this pile yet again to a small number of okays. These are returned to

Published in *The New Yorker* in the mid-seventies, Steig's series of "Fellow Men" captured every daily glance and grimace, from the mild dissatisfaction of a solitary diner to the inflated sense of importance held tightly around the throat of a society lady off on a mysterious mission.

the artists—accompanied, if necessary, by comments from the editor—to be redone as finished drawings. The finishes will be part of the following week's art meeting and, if purchased, prepared by the makeup department for publication. In 1973, that meant being photographed and then separated mechanically into line and half-tone film. Today, it means being digitally scanned and encoded on a computer disk.

The Seasonal Resident Reappearing

Man Drinking Pernod and
Smoking a Schimmelpenninck

Diner Watching a Later Arrival
Being Served Earlier

FELLOW
MEN

Man Listening to Beethoven's Ninth

Recipient of Strange Phone Call

Professor Greeting New Students
with Pleasantries

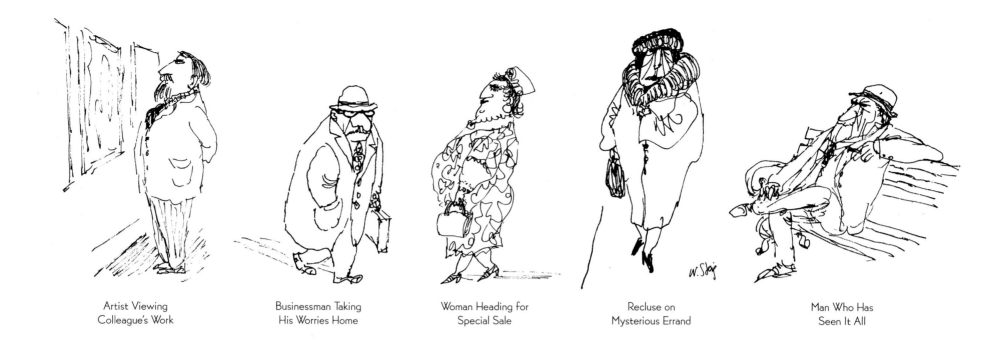

Artist Viewing
Colleague's Work

Businessman Taking
His Worries Home

Woman Heading for
Special Sale

Recluse on
Mysterious Errand

Man Who Has
Seen It All

A rough sketch often contains "happy accidents" that the artist feels unable to duplicate in the finish. Choice bits are often cut from these roughs and transplanted to the final drawings. Frank Modell and George Booth are especially partial to this approach, and their finishes often achieve the tactile richness of a collage. For the majority of cartoonists, producing the finished drawings is not the joyful activity most people imagine. Perfectionists like Charles Saxon regularly submitted two or three alternative finishes, and even George Price often seemed more anxious to improve a drawing than to sell it.

Only two artists I dealt with seemed completely free of these anxieties: Charles Addams, who viewed his work with a Zen-like serenity, and William Steig, who had transcended the problem of roughs altogether. At this point in his life, his roughs *were* his finishes.

Each Monday's mail would include an ordinary nine-by-twelve envelope addressed in Steig's neat, Spenserian hand to "The New Yorker Art Department." Inside, a handful of drawings on pieces of paper of various sizes and proportions were prudently sandwiched between two pieces of cardboard and secured with a rubber band. Although most of these drawings were captioned, they were not, in fact, cartoons in the usual sense. (Many years later, I learned that these "captions," which were invariably perfect, were only added by Steig to make the drawings salable.) Editing Steig's drawings meant sifting out anything that seemed to echo work already in our bank, and sharing with Shawn the pleasure of savoring the remainder at the art meeting. These were irresistible, and we greedily bought more than we could publish.

Occasionally, the weekly mailings from Steig were accompanied by a short note: comments on articles in a previous issue, questions about upcoming cover needs, or complaints about the rough handling of his drawings by the makeup department (a sore topic among the artists).

Gradually I came to realize that the various elements of Steig's weekly offering were of a piece. When I spread them out—the carefully addressed envelope, the short notes, the sketches—they flowed together seamlessly. Part of this effect was a question of scale. At a time when artists routinely used the side of an office building as a sketchboard, Steig's drawings seemed remarkably modest. Seldom larger than a standard sheet of paper, most were less than half that size.

The scale is determined by Steig's line, which has the same weight and flow when he is drawing as when he is writing. That writing and drawing are similar kinds of activity is an obvious fact, but in William Steig's case the two are virtually identical: "I enjoy the physical act of writing. When I was a kid, before I could spell, I'd take a pencil and some paper and sit for hours 'writing' a story." For Steig, the pleasure generated by the creative act is directly proportional to the degree to which it is spontaneous. At one end of the scale are drawings that seem to chart the undirected flow of his unconscious. Somewhere in the middle are his books for children and his captioned cartoons. At the far end of the scale are drawings cranked out for advertising, an activity that he equates with being forced to produce Disney trinkets in a Chinese prison.

According to Steig's children, his work habits have changed little over the years. They recall him seated upright in a working chair before a plain table. His work surface is illuminated by a goose-neck lamp. His tools, now as then, are simple: paper, pens, and a bottle of ink. Leaning forward slightly, he dips his pen in the ink and begins to move his left hand lightly across the paper. For an artist as sensitive as Steig,

Started in this position — moves on ground, but backward.
Feb. 17 — gets into sitting posture by herself.

Steig's line has the same weight and flow when he is drawing as when he is writing. In a journal he kept in the early forties, he recorded in words and pictures his newborn daughter Lucy's first attempts at walking (she would lift up her behind and bump backwards, like an "inchworm stuck in reverse").

having to stop mid-drawing to dip your pen is as intrusive as a blowout during the Indy 500 is to a race car driver. In letters to his young daughter Maggie, he describes with obvious enthusiasm the experimental pens developed by his brother Arthur, which combined the permanence of India ink with the convenience of a cartridge pen. Steig draws from the wrist, not, like most artists, from the shoulder, and from across the room it is impossible to tell whether he's producing a

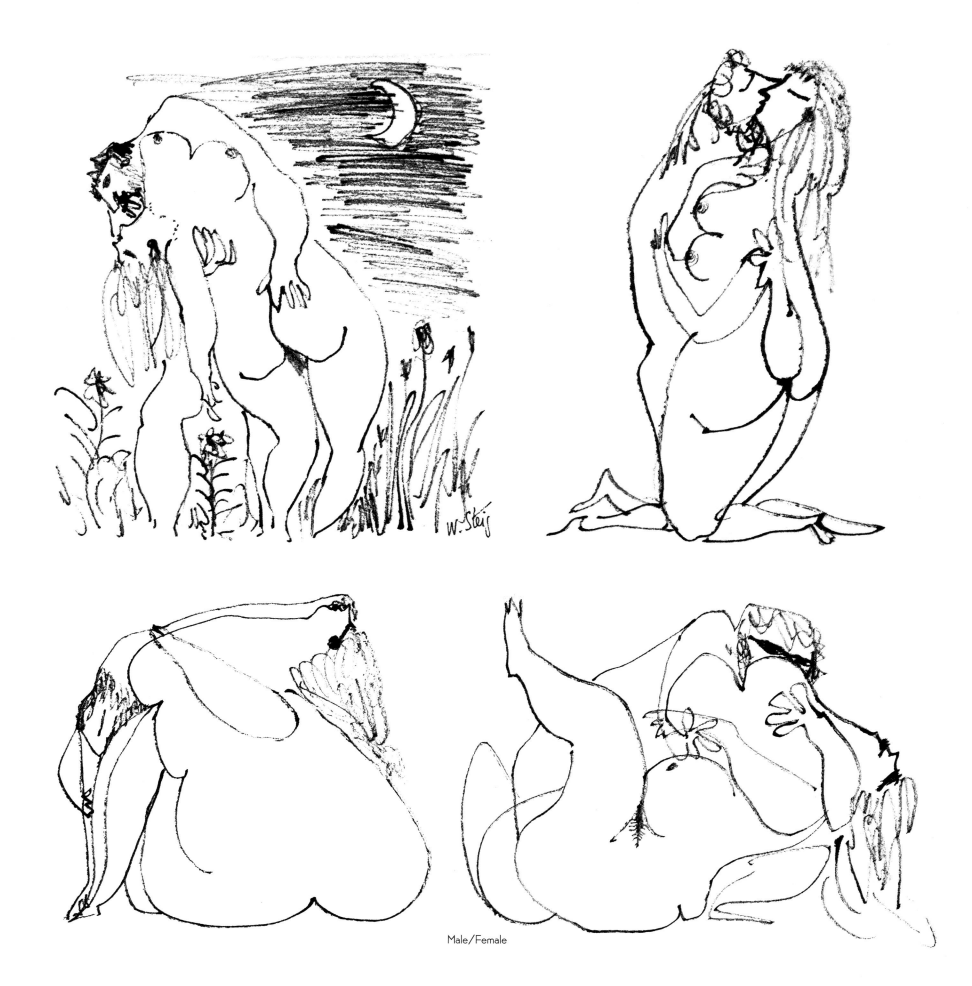

Male/Female

letter or a drawing. Steig considers drawing a magical activity, and on his drawing board, in addition to an ashtray, a pack of cigarettes, and some matches, there was often to be found a talisman of some sort, such as a metal ring his daughter Lucy had made for him some time ago. While the cigarettes and ashtray have long since disappeared, the lucky charms remain.

The French poet Paul Valéry once wrote that "all art is a forgery." That is to say, between the inspiration and its realization in whatever medium, there is the insuperable barrier of execution. In those moments spent mixing colors, sharpening a chisel, or transcribing a melody, the purity of inspiration turns stale. In retrospect, the course of Steig's career has been shaped by a sustained effort to remove those barriers and to allow his inspiration to spill directly onto the page. In his "Notes on Art," published in 1950 in the bulletin of the Orgone Institute, he wrote, "The so-called struggle of the artist is nothing but the struggle against the restraints, internal/external, of our irrational way of life." Steig seems to have won this struggle to a degree matched perhaps only by his inspiration, Pablo Picasso. (One thinks of Picasso's marvelous single-line drawings in light, photographed by Gjon Mili.)

From his first drawings, published in the thirties, William Steig's technical progress has been astonishingly swift. These early sketches were carefully conceived in pencil and ink with a loaded brush. After erasing the pencil lines, they were modeled in halftone washes. This effect was occasionally enhanced with charcoal, and then highlighted with touches of white. By the late thirties, the line was freer, and the outline sketches in dry brush. The halftone was being used in a more decorative manner. By the fifties, Steig had perfected a line that danced across the page, and in the sixties, at the suggestion of his son, Jeremy, he stopped preparing any kind of preliminary drawing: The last barrier to complete spontaneity had been cast aside.

One of the rewards of Steig's growing success as a creator of children's books in the sixties was his publishers' willingness to bring out collections of his extraordinary but less commercial work. The most unexpected and haunting volume is undoubtedly

The explicitly erotic drawings in *Male/Female* revealed a tenderness and sensuality never before seen in Steig's work. Expressions of love, as opposed to anger, they stood in sharp contrast to the clashing couples of earlier books.

Male/Female, published in 1971. The volume is a collection of work produced over the previous four years, including much material from *The New Yorker.* There is the usual contingent of battling spouses and bumbling swains, and, surprisingly, a group of stunning, explicitly erotic drawings. Steig's anxiety about the reception of this work was noted in a letter to his daughter Maggie. Lovers embrace, entwine, enfold, and seemingly melt into one another. There is nothing remotely similar to these drawings anywhere else in Steig's large and varied ouevre. The tone, intensely sexual yet innocent, is perfectly echoed in the introductory poem by Steig's brother Arthur:

Poem for My Brother's Book

How lucky we are
that our planet is not bald like the Moon

that its skin nourishes mushrooms and orchids
and enchambers waters and coals

that serpents find damp joys here
that bulls are made rapturous by cows
and Earth's gown of air carriers their bellows

that when at 5 AM the Sun squints
his wild vermilion eye over the rim of the world
the light is gathered by forests of flittering pennons

that no matter the rages of some Ages and some sons
our mothers are born and born again

In *Drawings, Ruminations, Our Miserable Life,* and *Strutters & Fretters,* Steig continued to explore his obsessions: the relationships between parent and child, man and woman, self and society.

Steig's publishers have never had difficulty recruiting distinguished writers to pen introductions to these collections. Albert Hubbell, Whitney Balliett, and William Saroyan have all had a go, along with Arthur Steig, and, of course, the artist himself. *Drawings,* published in 1979, includes a prefatory appreciation by Lillian Ross. In her words, Steig's world is "a place without money or machinery or things. It is a world populated by artists, farmers, knights, ladies, gentlemen, lovers (many, many lovers), by lions, dogs, cats, rabbits, chickens, birds, fish. Congenial creatures all of them, but with every human fault. By drunks, violinists, bums, actors, clowns, by those strange people who are, after all, fellow-men, and of course by children, an intimate, pastoral, not too dangerous world where poetry rules and time does not pass."

The sketches in *Drawings* are largely from *The New Yorker,* most of them uncaptioned, and include two of his most inspired spreads: "Scenes from Genesis and Exodus" and "American Beginnings" (page 94).

Drawings was followed by *Ruminations* in 1984, *Our Miserable Life* (a title Steig had been dying to use for over twenty years) in 1990, and *Strutters & Fretters* in 1992. In these four volumes, the preoccupations of a lifetime are revisited, revised, and refreshed. *Strutters & Fretters, Our Miserable Life,* and *Ruminations* bring the symbolic work of the thirties full-circle. *Drawings* includes several of the artist's most innovative spreads from *The New Yorker,* as well as a bouquet of previously unpublished work.

William Steig has published more than forty books and his work has been translated into twenty-two languages, yet, like most artists, he still believes his best work has never been set before the public. A portfolio of these drawings, selected by the artist himself, appears on the following pages. What is most striking about this assortment is what's been left out: There are no "Small Fry," no "Dreams of Glory," no *New Yorker* covers, and, most surprisingly, no symbolic work—in fact, no cartoons of any kind. Instead, what

The Pervading Melancholy

W. Steig

MY LIFE

The writer in his den

Animal, vegetable, mineral

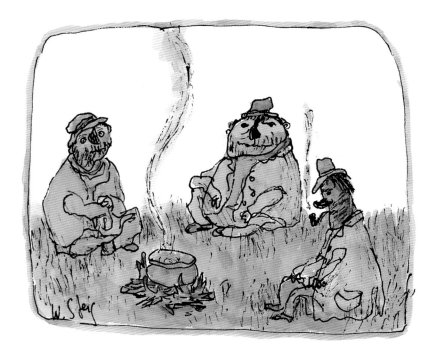

Mulligan's Stew

Ruminations

Pocket knife

Six cowboys on four horses

are offered are pure drawings, done spontaneously to please the artist, and he invites his audience to share with him the pleasure of unfettered creation. In his 1950 "Notes on Art" article, he wrote, "Internally, everyone functions like an artist, constantly creating mental pictures of his moving, changing whereabouts. These pictures are not 'photographic' but 'abstract,' the emphasis being on movement, direction, shape, texture, and so forth—the feel of things. This mental picture is a practical necessity of our everyday lives. The act of ardent spectator re-creates the painting, following the same paths of energy laid down by the artist. He experiences again what the artist experienced in making the painting: movement, emotion, glory,

Steig considers some of his most recent, unpublished, work to be his best. A portfolio of these illustrations, selected by the artist himself, appears on the following pages.

and man's boundless creative power and wonder—which is respect for life."

In this personally selected group of recent sketches, William Steig generously invites readers to share directly the deep satisfaction he experiences as his creations flow, unimpeded, through the artist's hand.

Fully rented

W. Steig

The Carnival

A Warm Autumn Day

Presumptuous Insect

Disagreement

Where the Bee Sucks there Suck I

STEIG AND HIS PEERS

In a society obsessed with polls and surveys—the Top 10, or 20, or 100—William Steig has steadfastly refused to play the rating game. He is justly proud of the awards he has received, but he has never altered a drawing, changed an opinion, or rewritten a paragraph with an eye toward winning friends or influencing juries. This said, it is also true that Steig is fully aware of his peers and his place among them. (In a letter from 1970, he refers to Saul Steinberg as "his competitor.")

So how does Steig's work compare with that of his contemporaries?

Set alongside the viscerally aggressive line of his *New Yorker* colleagues George Price and Peter Arno, Steig's drawings seem, at first glance, tentative, even fragile. On closer inspection, however, his seemingly casual line has an inevitability that gives it great tensile strength. In later years, Arno's brushwork became rather mechanical and Price's line brittle. Steig has somehow escaped this hardening of the artistic arteries, and his line is as supple and graceful as it was thirty years ago.

His symbolic drawings perhaps lack the coruscating rage of George Grosz, Ronald Searle, Robert Osborne, Ralph Barton, or Robert Crumb. But certainly the work collected in *The Lonely Ones* and *The Agony in the Kindergarten* is as insightful and ferocious as anything created by these satirists.

Early on, Steig established himself as a master of the visual pun, and his only rivals in this area are Saul Steinberg, and perhaps Tomi Ungerer.

As a creator of books for children, Steig has demonstrated over and over again a natural gift for entering the imaginative world of young people—a gift shared only with Maurice Sendak and E. B. White. Leonard Marcus, the critic, essayist, and author of *Margaret Wise Brown: Awakened by the Moon* (Beacon Press, 1992), puts Steig at the top of the list of children's book creators: "William Steig's best picture books—*Sylvester and the Magic Pebble, Doctor De Soto,* and *Brave Irene,* among others—belong in the first rank of books for young readers published in the United States in the last fifty years. As a comic storyteller, Steig has had perhaps only one peer within the genre,

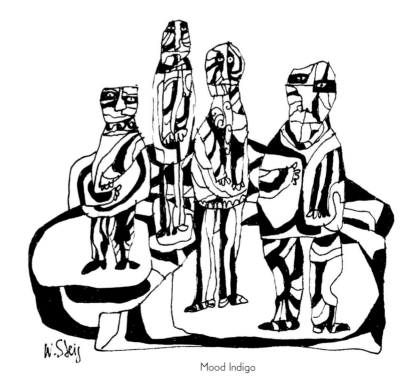

Mood Indigo

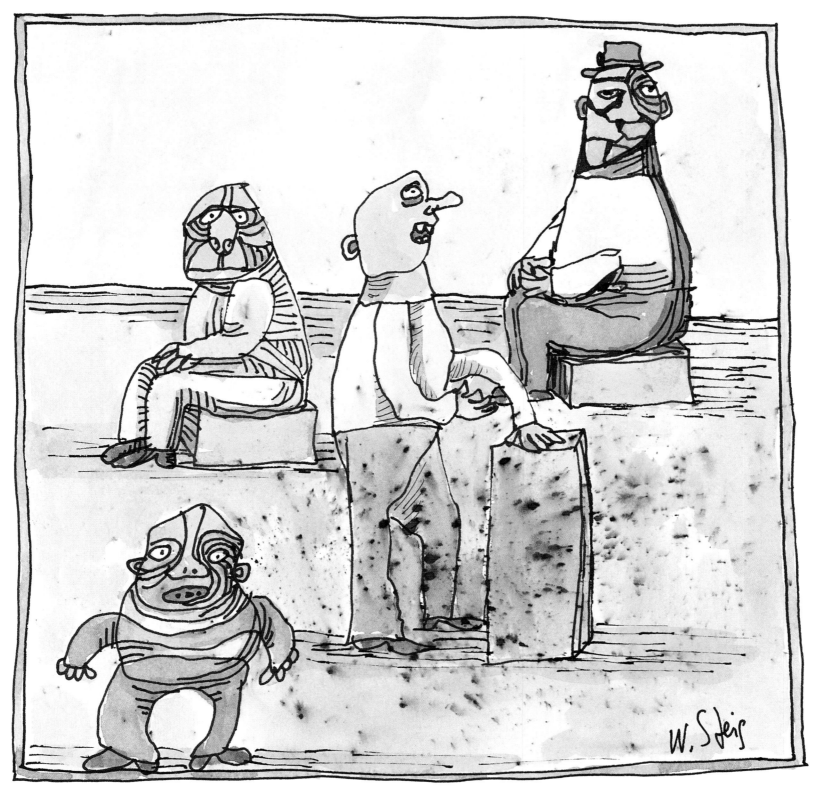

By the Sea

the late James Marshall. While Marshall was primarily a satirist, Steig writes in and around the traditions of the folktale and fable, in stories that combine moral gravity and a clowning irreverence, psychological insight, and a rapturous spirit of abandon. Steig writes elegantly, with subtle control over his material, but also with a kick-the-can directness that feels wholly purged of false sentiment, and authentically childlike . . . Blake's Tyger is generally on the prowl in the longer works, and to my mind *Abel's Island* contains some of the most exquisite expressions of wonder at the terrible-beauty-of-it-all this side of *Charlotte's Web.*"

Curiously, Steig has never used his art as a means of communicating a political point of view. During the Watergate hearings, while others cartoonists were using their medium to prove that the pen—or pencil, or paintbrush—was mightier than the sword, Steig kept his hands busy crocheting pastoral tapestries.

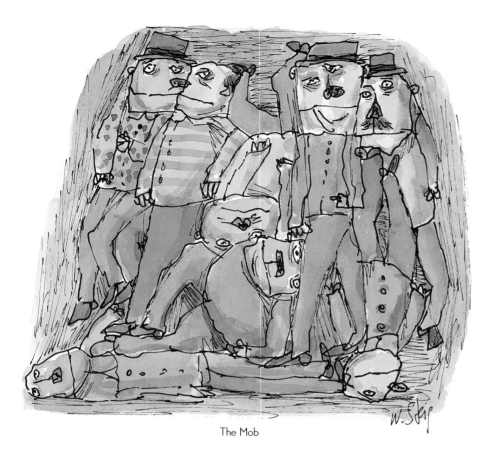

The Mob

As a chronicler of social mores, Steig is unsurpassed, but there remains a peculiar hole at the center of his worldview. Although he is the child of Socialist parents and an ardent champion of human rights, he has never used his art to comment on a specific political event or personality. (The heroic exploits of his "Small Fry" during the Second World War as he recorded them in *Dreams of Glory* are surely propaganda rather than commentary.) The explanation may lie in Steig's belief that we are crippled less by what others do to us than by what we do to ourselves. In any case, it is true that during the tumultuous Watergate hearings, while satirists such as Jules Feiffer and Edward Sorel were happily driving spikes into Richard Nixon's coffin, William Steig kept his hands busy crocheting the elegant, pastoral tapestries shown on the previous pages.

In his ability to portray the full range of human feelings, William Steig reigns unchallenged. (He has written, "I always begin with the face.") Love, hate, anger, remorse, sorrow—all these emotions are adequately portrayed by most artists. The subtler states of unrequited love, vague foreboding, self-denial, and existential angst have been captured by a few. But none has rivaled Steig's inventory of the public masks behind which the vulnerable self is hidden.

Although Steig consistently cites Picasso as his master, the demonic energy that permeates Picasso's work has no echo in Steig's. As colorists, they seem even further apart. Picasso's palette runs from the seductive chromaticism of Debussy to the acid dissonance of

Four Friends and a Guardian Spirit

Stravinsky. Steig's is as sunny as Schubert. Even in *Rotten Island* (page 164), Steig's color is warm and friendly. (Imagine how Picasso would have illustrated the same tale.) It could legitimately be argued that the artist Steig most closely resembles is Paul Klee. Like Klee, and unlike Picasso, Steig uses his gifts not to parade his own feelings but to elucidate the feelings of others. Like Klee, he works on a modest scale, shunning bombast and histrionics. Like Klee, Steig creates art that, at first glance, is deceptively naïve. And most important, his work, like Klee's, reveals an unsentimental but forgiving view of the human condition.

Although Steig has often cited Picasso as his mentor, Picasso's energy seems more egotistical, less sympathetic, than his. Modest in scale, lacking in histrionics, and deceptively naïve, Steig's art has much in common with the work of Klee.

Flirtation

"WHAT'S FUNNY ABOUT RED?"

In 1987, two years after he had purchased *The New Yorker* from the Fleischmann family, S. I. Newhouse replaced editor William Shawn with Robert Gottlieb, the head of one of his other principal holdings, Alfred A. Knopf Publishers. Steig was already long-established as *The New Yorker*'s signature cartoonist. Throughout the seventies, he had continued to contribute covers at a somewhat leisurely pace. Occasionally they echoed his increasingly successful children's books. But more often they were tied to the traditional holidays, particularly Christmas and, his favorite, Halloween. Gottlieb arrived with a mandate for change, and changes there were—in layout, in the increased use of photography, and, most important for Steig, in the reintroduction, for the first time since 1926, of color into the editorial pages of the magazine.

The artist chosen to inaugurate this new policy was William Steig. His "Scenes from the Thousand and One Nights" (February 20, 1989, see page 148) was the first of many spreads he produced for *The New Yorker* over the next five years. So great was Gottlieb's

Legend has it that, when asked about *The New Yorker's* reluctance to use color in its editorial pages, Harold Ross replied, "What's funny about red?" In 1989, Robert Gottlieb reintroduced color to the magazine with Steig's "Scenes from the Thousand and One Nights."

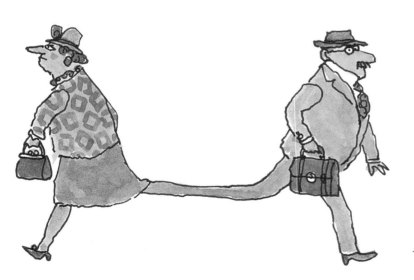

"Attachments"

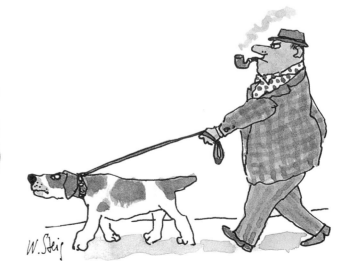

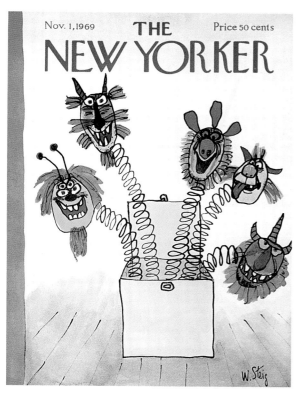

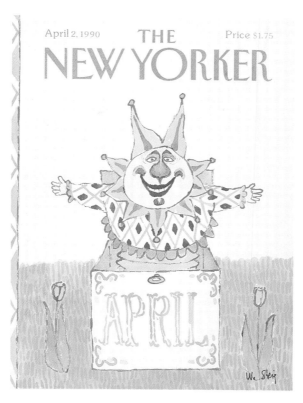

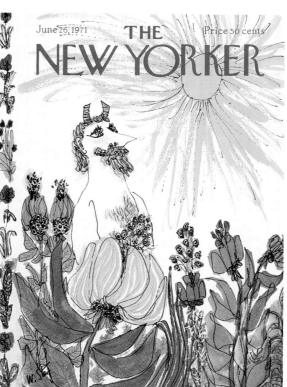

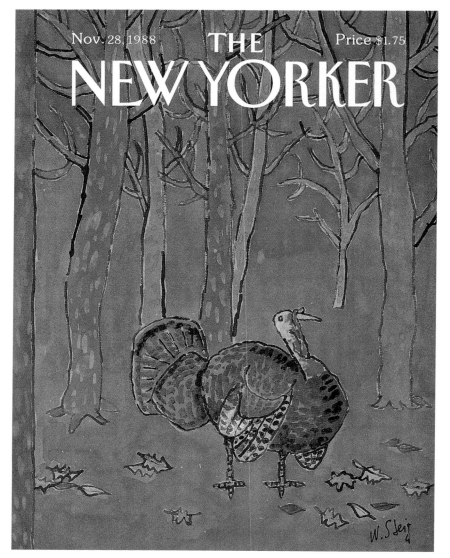

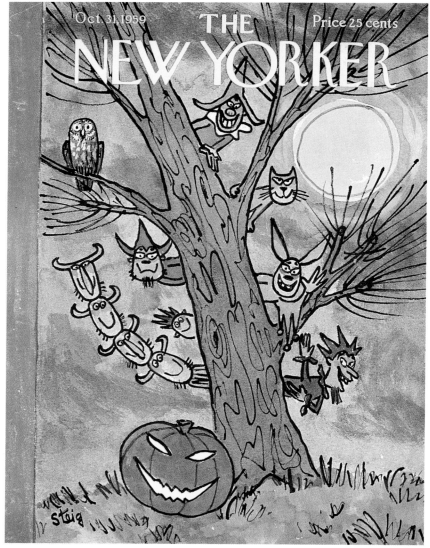

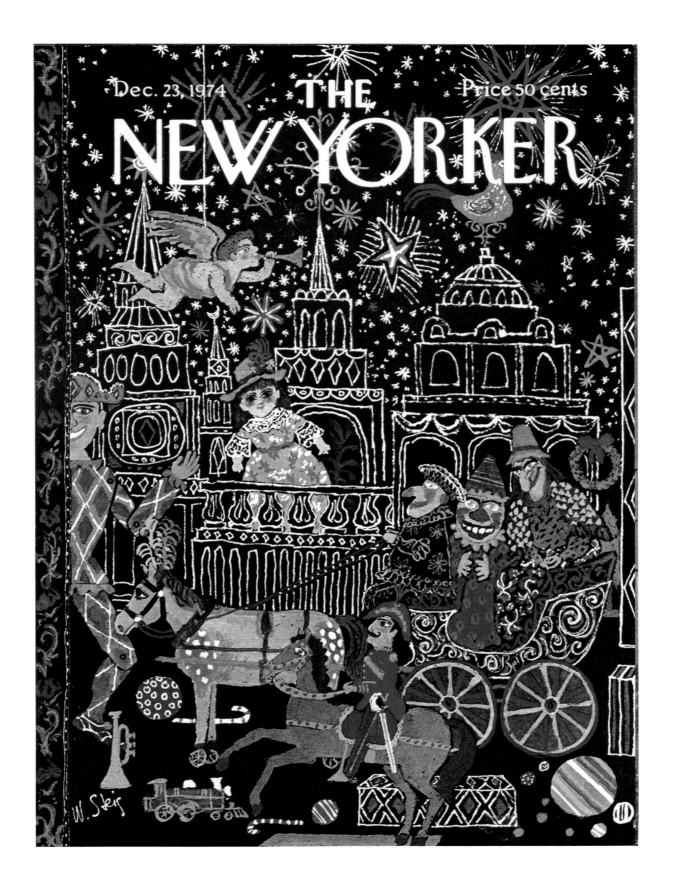

enthusiasm for Steig's color work that, by the time he was replaced in 1992, the magazine had a large unpublished inventory in its bank. This proved to be a bonanza for Tina Brown, the new editor. If Gottlieb had bought more color than could be run, Brown was running more color than had been bought. The backlog of pieces by William Steig was an invaluable resource during the hectic transitional period. For example, Steig's wonderful drawing of a fortune teller sadly contemplating her turkey client's future in a crystal ball was originally purchased as a Thanksgiving cover: Brown's desire to add a splash of interior color to an earlier issue resulted in its use as a full-page feature.

To this day, a significant collection of purchased but unpublished Steig drawings languish in *The New Yorker*'s vaults, trapped in a twilight zone somewhere between editorial enthusiasm and the shortage of space.

Since the time of Harold Ross, *The New Yorker* has traditionally purchased more material than it could print. Occasionally suggestions were made that this material be collected and brought out, either in special editions of the magazine or in separately published volumes. It's difficult to imagine a more distinguished collection to initiate such a series than the unpublished color work of William Steig.

"Scenes from the Thousand and One Nights" was one of several color spreads Steig produced for *The New Yorker* under Robert Gottlieb. Because the magazine has always purchased more material than it could print, it also holds several unpublished Steig drawings in its cartoon banks. Beginning with the "Royalty" spread on page 152, a selection of such unpublished drawings closes the chapter.

RELATIONSHIPS

Companions

Business Partners

SCENES FROM THE THOUSAND AND ONE NIGHTS

Pretending to be asleep, King Massoudah overhears talk about his wife's infidelity.

The old man gets tipsy and relaxes his grip on Sindbad.

Ali Baba's brother, Cassim, forgets the magic word and is locked in the cavern.

Ma'aruf, the poor cobbler, is tormented by Fatimah, his shrewish wife.

AFFLICTIONS

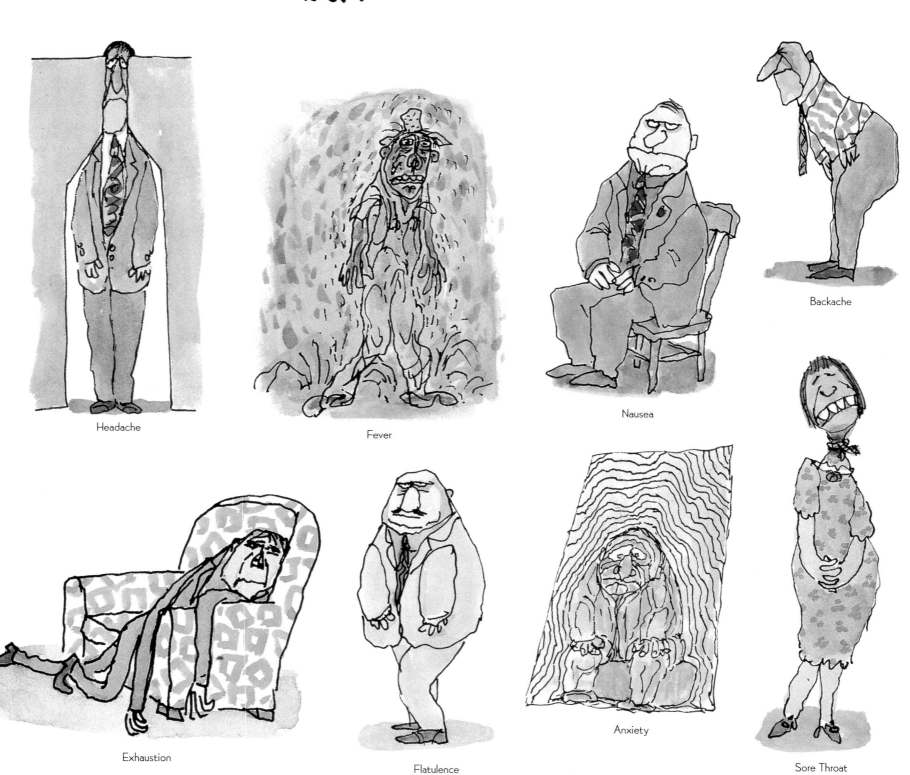

Headache

Fever

Nausea

Backache

Exhaustion

Flatulence

Anxiety

Sore Throat

NAGGING QUESTIONS

"What did I ever see in her?"

"Just whom did she mean when she said,
'There are some people who. . .'?"

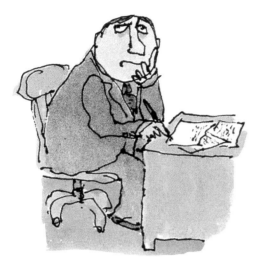

"How should I say it?"

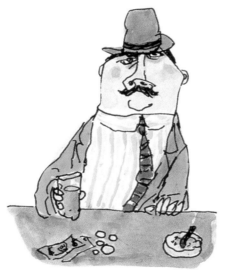

"Why do I take so much of his crap?"

"Where the devil did I put my glasses?"

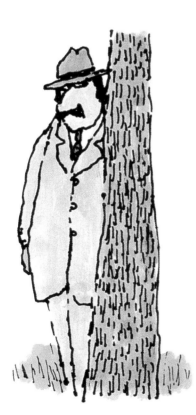

"Should I kill him now?"

"Am I as stupid as I feel I am?"

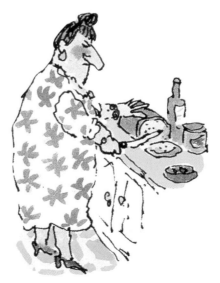

"Why did I marry such a jackass?"

ROYALTY

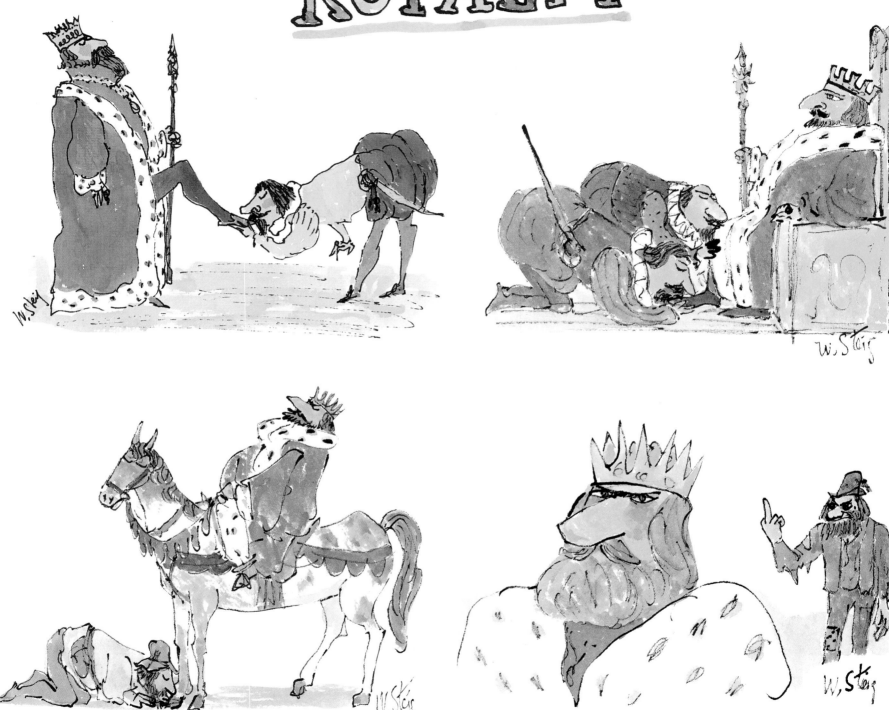

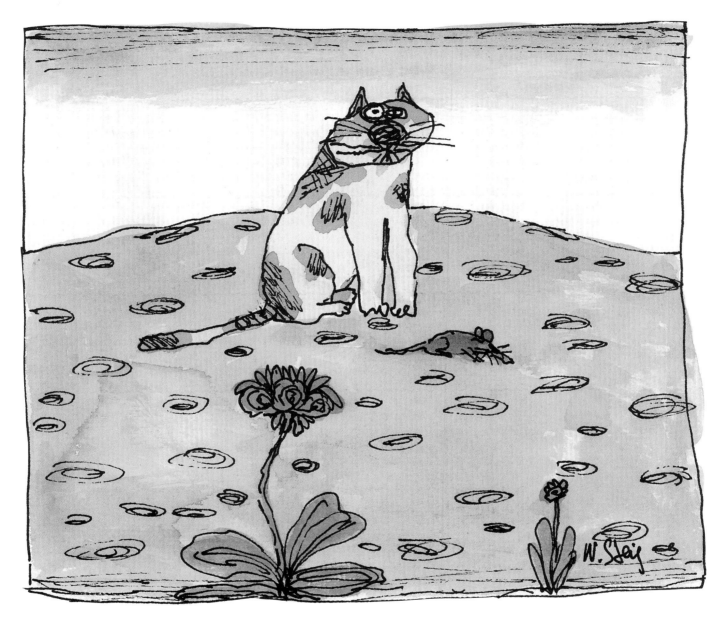

Existential Guilt

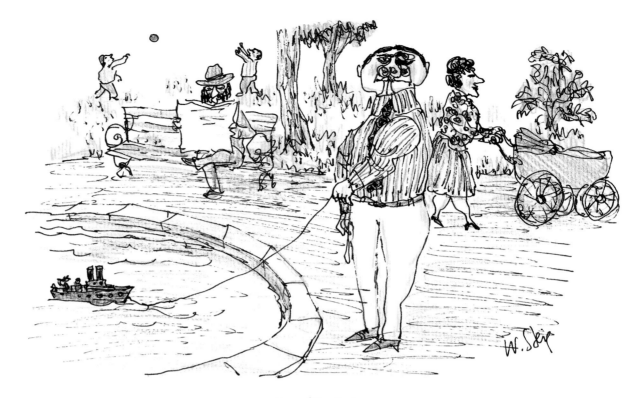

None of Your Business

A Rare June Day

A Pause in the Day's Occupation

A Sweetheart, a Swain, a Swine, and Some Swans

Love at First Sight

Satyr

THROUGH
THE EYES OF
A CHILD

Steig's youngest daughter, Maggie, remem-

bers her dad as not only a parent but also a

childhood playmate: "He could enter into

any activity with the same sense of wonder

and enthusiasm as a kid. He was great at

telling stories and making up games. After

he and Mom divorced, he used to take

me home on the subway at the end of our

weekends together. During the ride we would play 'What Would You Rather Be?' For example, 'Would you rather be a knee or an elbow?' We'd discuss the pros and cons: A knee can see everything coming; on the other hand, nobody can sneak up on an elbow, because it can see everything behind it."

Steig's son, Jeremy, recalls his dad reading to him and his sister Lucy: "Dad was a wonderful reader. Not the usual kids stuff. There was *Moby-Dick, The Call of the Wild.* He was great, acting out all the parts." (This was a family trait, honestly come by. Steig's father was a spell-binding raconteur, who starred in most of his own tales.)

Beginning in the fifties, everything in Steig's work seemed to point to a blending of narrative and drawing: his turning away from gag cartoons toward a more personal form; his growing mastery as a colorist;

and, of course, his natural gifts as a writer. In spite of all this, Steig's first children's book, *CDB!*, was not published until 1968. The natural question is: What took him so long? According to his wife Jeanne, the answer is simple: "Bill likes to be asked." And up until then, no one had. The person who finally did was a fellow cartoonist and *New Yorker* colleague, Robert Kraus.

Steig's fondness for wordplay is evident in his very first book for children, the irresistible *CDB!*, and in its companion volume, *CDC?* Letters are used to mimic the sounds of words. Pictures help to figure out the puzzle.

F-N

L

T-D-M

B-U-T N D B-S

Bob Kraus began publishing in *The New Yorker* in the fifties. Though he was a prolific idea man, his early career was hobbled by an undistinctive drawing style. Some sage advice from art editor James Geraghty moved his work in a more personal direction. By the early sixties, his full-page drawings, a compelling blend of the slapstick and the sinister, were appearing regularly. He also began producing covers in a Birnbaum-inspired style, richly colored and highly tactile.

Soon Kraus was producing more work than the magazine could publish. Ambitious, inventive, and restless, Kraus sampled almost every other possible outlet for his talent. He composed rock and roll songs, he tried his hand at fiction, and he even produced a low-budget horror film, shot with amateur actors—including me—in the basement of his house. (The finished cut of *Swat* never made it to the nabes, but

Kraus did manage to sell a four-page spread of stills to a magazine called *Great Horror Films of Hollywood.*)

Eventually, Kraus hit on children's books and had an immediate success with *The Bunny's Nutshell Library,* a series of four books published by Harper & Row in 1965. By the late sixties he was doing so well that he decided, with the backing of Simon & Schuster, to launch his own imprint, Windmill Books. It was Kraus's inspiration to recruit some of his *New Yorker* colleagues for his first list. Whitney Darrow, Jr., was an early participant, as was Charles Addams, who produced a classic version of Mother Goose. Then, in 1968, Kraus turned to William Steig. On some level, he must have been waiting for the call, for as Kraus remembers, Steig "exploded" with ideas. *CDB!,* the first to be published, reads like a bedtime game improvised by an artist for his children—although

Roland the Minstrel Pig

none of Steig's kids remember their father playing such a game. The captions are written in a kind of letter code, at just the right level of challenge and surprise for a youngster, and the drawings are appropriately wacky. Best of all, the whole confection comes across as spontaneous and effortless. If *CDB!* was successful on its own terms, it was a rather forgettable hors d'oeuvre compared to the banquet that was to follow.

Steig's second book offered a stronger hint of what lay ahead. *Roland the Minstrel Pig,* published the

same year as *CDB!,* introduces themes that appear again and again in Steig's later works. Roland is a strolling balladeer who accompanies his "clear, sweet voice" with a lute. He is a romantic, in love with life. He is a wanderer, an innocent, whose natural gifts lead him to triumph over his enemies.

Under starlit skies, Roland serenades his friends. The world is a beautiful place. But evil is part of the world also, and Roland is saved from becoming a fox's dinner by a passing king who overhears Roland's swan song:

> Farewell, dear world, dear hill, dear shore,
> Dear butterflies, dear birds, dear bees,
> Dear night, dear day, dear seasons four,
> Dear flowering fields, dear fruited trees,
> Dear warming sun, dear gentle breeze.

These laments are saved from sentimentality by a cleansing dash of reality in the tune's last three lines:

> My heart's so sore
> I'll be no more.
> I feel an aching in my knees.

refuted on every page of Steig's children's books. It is true, however, that he *feels* any limitation imposed on the free flow of his fancy to be an intolerable burden. Perhaps this explains why he considers his next book, *Bad Island* (1969, later published in 1984 as *Rotten Island, overleaf*), to be one of his favorites. From its thundering overture to its pastoral coda, *Rotten Island* is a visual jam session, every page boiling with the pure joy of unfettered creativity. In the story, a sulfurous, wretched island populated by death-loving creatures is invaded and ultimately transformed by a single flower. The island and its inhabitants are in a state of constant transmogrification as a consequence of its peculiar climate and the beasts' murderous habits. On this skimpy armature, unrestricted by a need for recurring scenes or characters, Steig indulged every whim of his imagination. On Rotten

Steig has often complained about the limitations of illustrating children's books. In Jonathan Cott's perceptive essay on Steig in his book *Pipers at the Gates of Dawn* (Random House, 1983), the artist declares, "I don't like illustrating because it's not very spontaneous. When I'm illustrating, I know a character has to walk a certain way, and I have a hard time doing it. I'm incapable of making drawing conform to the requirements of telling a story, making a pig look like the pig on the previous page." This wildly inaccurate statement is

Sylvester and the Magic Pebble

Island, the flora is as repulsive as the fauna, and Steig's obvious pleasure in depicting earthquakes, volcanic eruptions, icy death, and the ferocity of battle is as intense, and as innocent, as that of a child. A healing rain and an Edenic finale provide a satisfying landing to what every child experiences as a breathtaking ride.

The same year produced a much gentler fable, *Sylvester and the Magic Pebble,* which won Steig his first Caldecott Medal. Sylvester Duncan, a donkey, the only son of doting parents, collects rocks. One day he finds a remarkable specimen, "flaming red, shiny, and perfectly round." Heading home to show it to his parents, he is threatened by a lion. Fleeing in terror, with pebble in fist, he wishes to become a rock—and does. As his frantic parents search for Sylvester, he endures the changing seasons in his rock prison. The magic pebble, tantalizingly close but untouchable, is his only companion. Spring arrives, and Mr. and Mrs. Duncan are drawn by it to the countryside. Mr. Duncan picks up the pebble, and as they seat themselves unknowingly on the rock that is their son, Mrs. Duncan wishes for his return. Magically, Sylvester is freed, and the family is ecstatically reunited.

Perhaps there is a connection between Sylvester's transformation and Reich's theory of body armoring (an interpretation Steig steadfastly resists). Whatever the meaning, the theme of personal evolution physically manifested is one that Steig returns to over and over, particularly in *Caleb & Kate* (1977), *Solomon the Rusty Nail* (1979), and *The Toy Brother* (1996). Although *Sylvester and the Magic Pebble* became one of Steig's most popular books, one group among its readership was not amused. In their search for their son, Mr. and Mrs.

Duncan enlist the help of the local police, who are portrayed as pigs. In the late sixties, the notion of police as pigs was offensive, at least to those who wore the badge. In December 1970, the Illinois Police Association sent out a letter to all law-enforcement officers which read, in part, "The book [*Sylvester and the Magic Pebble*] contains a full-color picture depicting a law-enforcement officer as a pig and the public as jackasses. It is written for our youngsters in their formative years, five to eight. The picture shows two jackasses [Mr. and Mrs. Duncan] requesting advice from the police, and has the police officers as pigs, dressed in police

On a rainy Saturday, Sylvester found a quite extraordinary pebble. When he held it in his hoof and wished aloud, whatever he asked for came true.

uniforms. This most certainly must mold the minds of our youngsters to think of police as pigs rather than as their good friends." (This is the only picture of pigs in the book.)

The innocent Sylvester became a victim of the hippie backlash of the seventies. *Sylvester and the Magic Pebble* was banned from libraries in Nebraska, California, and Ohio, and the artist himself was moved to write an essay defending his position. It appeared in *The New York Times.*

In 1970, *Sylvester* was followed by two more "word" books, *The Bad Speller* and *An Eye for Elephants.* Steig has characterized these as "mistakes," but they

An Eye for Elephants

From the classic childhood rhyme "I asked my mother for fifty cents, to see the elephant jump the fence," readers depart on an antic trip to Elephant Land in *An Eye for Elephants*. *Amos & Boris* explores the unlikely friendship between a mouse and a whale.

have both charm and staying power, as evidenced by the fact that they are both still in print. Steig's love of wordplay is often mentioned in his contemporaneous letters to his daughter Maggie (page 196).

An Eye for Elephants was Steig's last book for Bob Kraus's Windmill Press. Almost thirty years later, the feelings that led to this rupture are still strong on both sides. One of the unintended victims of the falling out was a proposed animated version of *Sylvester.* Steig mentioned it often and enthusiastically in his weekly

letters to his daughter Maggie. Part of his excitement had to do with the prospect of working with two friends he admired greatly: the painter and animator Lee Savage, who was scheduled to direct the film, and Steig's son, Jeremy, who was to provide the music. There have been some memorable animated versions of Steig's work, but, considering the ingredients, one must share Steig's disappointment at this lost opportunity.

In Steig's next book, *Amos & Boris* (1971), a pair of unlikely companions, divided by size, habitat, and temperament, forge a deep bond of friendship. Amos, a mouse, is born with a love of the sea. Fulfilling his ambition, he launches a small boat and, floating on a phosphorescent ocean that seems to melt into the star-filled heavens, he experiences a sense of cosmic unity (a state described repeatedly in Steig's books for children). Amos rolls over board and is saved by a passing whale, Boris. Through their relationship, Steig tenderly examines man's essential loneliness, and the pleasures, and limitations, of friendship.

Amos & Boris was Steig's first venture with a new publisher, Farrar, Straus & Giroux, and, more important, a new editor, Michael Di Capua. For an artist as inner-directed as William Steig, a change of editor might seem inconsequential, but in this instance it marked the beginning of a long and fruitful collaboration. Di Capua encouraged Steig to move beyond the picture book format and to write with a freedom and complexity rarely found in works for children. This resulted in three of Steig's most extraordinary books: *Dominic* (1972), *The Real Thief* (1973), and *Abel's Island* (1976). All three are, in publishing jargon, "text-driven." The drawings, charming black-and-white sketches, adumbrate

Amos & Boris

Dominic

and the pungent scents of the forest: "Dominic walked along in silence, smelling all the wonderful forest odors, alert to every new one, his nostrils quivering with delight. He smelled damp earth, mushrooms, dried leaves, violets, mint, spruce, rotting wood, animal droppings, forget-me-nots, and mold, and he savored all of them. The odors came as single notes or percussion shots, or fused together in wonderful harmonies. Dominic was inspired to take out his piccolo and play. He invented a melody which he decided should be called 'The Psalm of Sweet Smells.'"

In his travels, Dominic learns about friendship, the joys and sorrows of family life, loyalty, courage, cruelty, treachery, and death. *Dominic* is, in fact, a meditation on good and evil disguised as a book for children. Dominic's nemesis, the Doomsday Gang, has only one redeeming quality: energy. (Dominic reluc-

Dominic's got a heart of gold, nerves of steel, and all the talents of a Renaissance dog. Elated by the odors of the forest, he plays "The Psalm of Sweet Smells" on his trusty piccolo and howls at the moon.

the characters and nudge the imagination, but it is the rhythmic, energetic prose that carries the reader forward.

Like Roland in *Roland the Minstrel Pig,* the eponymous Dominic is a musician. He also shares Roland's taste for adventure. Leaving a note of farewell for his friends, he sets out with nothing but his bandanna, his piccolo, and a seemingly endless supply of hats. Dominic's tale is full of surprises, and Steig mixes the magical and the mundane in the same matter-of-fact tone.

Dominic is a dog, experiencing the world through the senses of a dog, and readers are transported, as Dominic is, by his response to the star-spangled heavens

tantly admits to himself that he admires them more than their helpless, self-pitying prey, the rabbits.) Although Dominic defeats them again and again, they are finally destroyed only when the forces of nature itself react in outrage to their shenanigans.

The fabric of Steig's world is woven from the woof of imagination and the warp of reality: witches' spells, dancing pigs, singing dogs, ecstasy, transport, death. But evil—blind, unthinking evil, as epitomized by the demonic characters of Rotten Island and the Doomsday Gang—is outside of the natural order. Dominic has spent his life resisting evil, but finally only nature can set matters straight. As Dominic lies sleeping, the Doomsday Gang seizes the opportunity to dispatch him once and for all. As the gang closes in for the kill, the trees of the forest find their tongue: "At that moment, the surrounding trees bent toward the villains, saying, 'For shame! Fie!' The terror of this experience, the condemnation from the lords of the hitherto silent vegetable kingdom, had penetrated to their souls. Convinced that nature itself could no longer abide their destructive criminal ways, they each

slunk about separately, making efforts to reform, and get into nature's good graces again, as every one of them had been in his original childhood." The noble Dominic is firmly linked to life by his senses. The members of the evil Doomsday Gang are in fact sense*less,* incapable of touching, smelling, seeing, hearing, or feeling the world around them.

The traditional reward for the hero is the hand of the princess, and Dominic is no exception. When they meet, she is attended by a peacock. "Are you the one?" she asks. The couple embraces and, in a marvelous final twist, they do *not* settle down to live happily ever after. Joining paws, they leave the enchanted castle to seek new adventures, together.

Dominic is a book for children in the same sense that *Alice in Wonderland* is a book for children. Both offer characters and situations to delight youngsters, and intellectual meat for adults to digest. Dominic, of course, is fully engaged in his adventures, while Alice

The Real Thief

is a relatively passive observer. Lewis Carroll's world is hermetic, cold, cerebral. Steig's, passionate, mysterious, and life-affirming. Nowhere else in the artist's work does he so completely lay out his view of the universe and man's place in it.

In *The Real Thief,* Steig descends from the Olympian perspective of *Dominic* to examine narrower questions of guilt and innocence, conscience and honor. Gawain the goose is the devoted servant of King Basil and the guard of the royal treasury. He is wrongly accused of theft when the famous Kalikak diamond disappears from the treasury vaults, to which only he and the king have keys. The missing loot includes twenty-nine rubies, a hundred and three gold ducats, several silver ornaments, and the diamond itself. Cruelly denounced by the monarch he has so faithfully served, Gawain is taken to trial, found guilty, and about to be led to the dungeon when he escapes. In a device used in none of his other books, Steig reveals the true thief through a flashback. A mouse named Derek, readers learn, had been looting the treasury through a convenient mole hole, decorating his little mouse home to shore up his sagging self-image. Conscience-stricken by his part in Gawain's disgrace, Derek cleverly reveals Gawain's innocence by continuing to loot the treasury long after Gawain disappears. Having cleared Gawain's name, Derek now attempts to clear his own conscience by returning the remaining booty through the mole hole. But although the loss has been made whole, a pall of gloom hangs over the kingdom, a cloud of bad faith blotting out the sun. Finally, after a long search, Derek locates Gawain, who has been hiding in a nearby cave. Derek confesses, and Gawain forgives him. Gawain, however, has resolved

never to return to the kingdom and the king who had falsely accused him. As they talk, Derek brushes Gawain lightly. The comforting touch of a fellow being causes Gawain's resolve to melt. He realizes how much he misses contact with the world and returns to once more serve his liege. The story having reached the traditional

In *The Real Thief*, Steig tips his hat to his beloved Knights of the Round Table with Gawain the goose, a faithful servant of King Basil falsely accused of robbing the royal treasury. Farmer Palmer has more practical problems on his mind: His trip home from the market is no hay ride.

happy ending, Steig characteristically salts it with a few grains of common sense: "There was peace and harmony in the kingdom once again, except for the little troubles that come up so often even in the best of circumstances, since nothing is perfect."

In 1974, Steig returned to the more familiar picture-book format in the delightful *Farmer Palmer's Wagon Ride. Farmer Palmer,* like the Dewey Thruway, is the kind of near-rhyme that kids find irresistible. The misadventures of the farmer and his hired hand, Ebeneezer, a mule, on their way home from market are recounted in Steig's usual brisk prose and accompanied by unusually detailed drawings. The book is one of the artist's favorites. The farmer's gifts to his family—a bicycle, a toolbox, and a camera—are all recruited as solutions to one disaster after another. The tone is warm and low-key, and the mood playful. (Steig's editor's name appears on the mailbox in front of a decrepit-

Farmer Palmer's Wagon Ride

looking farmhouse.) In one of the warmest and funniest homecomings in all of Steig's books, the exhausted Farmer Palmer finally arrives on the bicycle purchased for his wife, carrying on his back the injured Ebeneezer.

In 1976, Steig's extraordinary trilogy for children, begun with *Dominic* and *The Real Thief,* was completed with the publication of *Abel's Island.* Most of his protagonists seem to spring from vaguely sketched, usually rustic backgrounds. Abel is a rare exception. His full name, Abelard Hassan DeChirico Flint, of the Mossville Flints, announces him as a solid member of the mouse middle-class. His courtly manner, rigid view of the world, and innate sense of decency are reminiscent of Evan Connell's *Mr. Bridge.* In twenty short chapters, Steig creates a compelling portrait of a conventional fellow forced by circumstances to examine, and then redefine, his sense of self.

At a rather formal country outing, Abel is separated from his wife and the rest of their party when he attempts to retrieve her scarf, which has been torn off in a sudden storm. Exhausted and lost, he collapses into sleep. When he awakens, he finds himself marooned in a tree, on an island. His attempts to escape by constructing a boat, then a bridge, and then a tunnel all fail. He weeps in frustration as he thinks of his dear wife, and calls on his lucky star for help. "What shall I do?" he asks. "You will do what you will do," the heavens reply (a clear echo of the crocodile witch's gnomic advice to Dominic). More exotic attempts, including building a catapult and a glider, also fail. Reluctantly, Abel begins to accept the island as his prison, and a log as his home. He dreams of his wife, Amanda, and these dreams expand into a kind of communion, a shared consciousness. His

heightened sense of nature breaks down the walls of his island prison, and he experiences moments of transcendence. The artistic side of his own nature flowers, and he begins to sculpt figures out of clay. First his wife, then his mother, then his brothers, and finally his father, "a proud, strong, aloof, honest, male parent." As Abel's former life is transformed into works of art and imagination, the reality of his new life begins to intensify. He imprints clay tablets with his name and scatters them about the island, marking his territory. He finds a book, and renews the pleasures of reading. He encounters his first enemy, an owl, and barely escapes. He arms

Stranded on an island, Abel is forced to reconsider his identity. Gradually, he re-creates himself as an artist, a philosopher, and a mouse for all seasons.

himself and ponders a natural order that includes such beasts of prey. He survives a bitter winter and a "dark night of the soul." His ability to commune with Amanda seems blocked by the cold winter air. Finally, spring arrives, at first reluctantly and then in a rush. Buds form, flowers bloom, and geese chatter overhead. Abel makes a friend, a frog named Garver. Garver is amiable, but unpredictable, and given to slipping into swoons. Abel sculpts his friend in clay. "I believe," says Abel, "it's the best thing I've ever done." "A work of art," agrees Garver admiringly.

When Garver leaves the island to search for his own family, he promises to send help. To divert himself

Abel's Island

Abel's Island

as he waits, Abel throws himself into his art with new passion. He sculpts plants and bushes, and learns to draw on bark with charcoal. As the days grow longer, the river level begins to drop. Finally, Abel is able to ford the riverbed, and he heads home. But his dreams of returning to Amanda seem doomed when he is attacked by a cat. Seeking refuge in a tree, he once more ponders the role nature has cast for each of us, cat and mouse. Eventually he escapes and reaches his hometown. Everyone is enjoying the full moon in the park. Abel staggers past them to his own doorstep. He enters his empty house, and falls into an exhausted sleep on the sofa. As he sleeps his wife returns. She sees her scarf in the hallway, and the book ends with the couple in each other's arms. Their reunion is celebrated in four textless drawings: Words would break the spell.

Abel's Island is Steig's last novel for children, and perhaps his richest. Whereas *Dominic* is a picaresque tale whose central character emerges undamaged, but unchanged, *Abel's Island* presents a remarkably convincing portrait of a decent, conservative fellow who, removed from his cozy, predictable life, gradually re-creates himself as an artist, a philosopher, and a mouse for all seasons.

The same year, Steig produced *The Amazing Bone,* featuring his first feminine heroine, Pearl the pig. Although they share the same name, Pearl seems less related to a cartoon character that Steig marketed in 1955 as a doll named Pitiful Pearl than to another heroine who appears some years later in his works, Brave Irene. Pearl is one sweet swine, but the real star of this charmingly illustrated picture book is the magic bone dropped by a passing witch. As in *Roland,* the

An irrepressibly articulate bone sees Pearl the pig through countless contretemps with a dastardly fox.

The Amazing Bone

this point in Steig's career, his readers no longer require such magical events to be explained, and in the book no explanation is offered.

The following year, Steig created *Tiffky Doofky,* a book with a plot that seems to be pure free association. It involves a fortune-telling goose, an emerald necklace, a malevolent chicken, a lady sorcerer, a demonic cat, a wacked-out butterfly collector, and a boa constrictor who is the pet of the heroine, Esmeralda. The ambling

Caleb & Kate

"Caleb the carpenter and Kate the weaver loved each other, but not every single minute." *Caleb & Kate* deals with one of Steig's constant themes, love's power to transform. The plot of *Tiffky Doofky* seems pure free association.

villain is once again a fox, and the happy ending is tempered by the bone's irrepressible loquaciousness.

In 1977, Steig returned to a favorite theme, transformation, and for the first time cast his stars as human beings. Caleb and Kate are a passionate couple, he a carpenter, she a weaver, whose deep love for each other is regularly tested by violent arguments. After one such battle, Caleb storms off into the woods, where, exhausted, he falls asleep. A passing witch uses the opportunity to try out a new spell, changing Caleb into a dog. He returns home and joins Kate in her frantic search for himself. Imprisoned in a dog's body, Caleb can only worship Kate in his heart. The witch's spell is broken when Caleb is injured while defending Kate from burglars. The lovers embrace ecstatically. At

Tiffky Doofky

story line is greatly enhanced by some of Steig's most charming drawings, and it leads to a happy ending in the blush of an effulgent sunset.

The world of children's books is a narrowly restricted one. Editors, librarians, and critics battle one another, but are united in the notions of what is or is not permissible in terms of subject matter, language, and art. Throughout Steig's career, he has been blessed with editors and publishers who have had the good sense, and courage, to give him a free hand. The wisdom of this strategy is proven by the results. Steig's text uses vocabulary and concepts that stretch a child's skills, and his drawings demand full engagement. In *Gorky Rises,*

Gorky Rises

Yellow & Pink

published in 1980, he offers one of his most daring and delightful creations. Though it is superficially a dreamy tale of flight, the obvious sexual subtext is matched in contemporary works for children only by Maurice Sendak's *In the Night Kitchen* (HarperCollins, 1970). The ecstatic pleasure that Gorky the frog experiences when flying turns to panic when he realizes that he has soared beyond home and family. Only by controlling the flow of his magic potion can he return. He does so, of course, and in the process crosses the threshold from adolescent sexual anxieties to full manhood.

The heavy Freudian symbolism of *Gorky Rises* was followed in 1984 by a sly spoof of evolutionary biology, *Yellow & Pink.* Two wooden figures try to imagine what they are and where they come from. Gradually, they answer these questions to their satisfaction, leaving unresolved only the problems of eyes and ears.

Suddenly, they are hauled off by a large fellow badly in need of a haircut:

"'Who is this guy?' Yellow whispered in Pink's ear. Pink didn't know."

Yellow & Pink manages to tweak both Darwinists *and* creationists at the same time.

One of Steig's most accessible and successful books, *Doctor De Soto*, appeared in 1982. It won a Newbery award, and Weston Woods released a charming animated version of the story on video. Having committed himself to treating a duplicitous fox, the briskly efficient mouse dentist of the title finds himself torn between anxiety for the safety of himself and his

Doctor De Soto Goes to Africa

Doctor De Soto

A "one-in-a-million, humdinger of a dentist," Doctor De Soto travels the world, curing the animal kingdom of its toothaches.

wife and a deep sense of professional responsibility. "I always finish a job," he tells his wife, "My father was the same way." The object of Doctor De Soto's concern, and his nemesis, is Steig's favorite heavy, a fox. Although the fox feels gratitude toward Doctor De Soto for having relieved him of a painful toothache, these feelings are overwhelmed by his deeper, dastardly fox nature. The text is funny, the pictures are magical, and the resolution deeply satisfying—the good doctor demonstrates that sharp teeth are no match for sharp wits. The popularity of the De Sotos led to a reprise of the entertaining couple in 1992's *Doctor De Soto Goes to Africa*.

In 1985, Steig spun one more tale of transformation. Although *Solomon the Rusty Nail* somewhat echoes *Sylvester and the Magic Pebble,* there are instructive differences. Solomon Rabbit's ability to morph into a nail is a special talent, and, unlike Sylvester's transformation into a rock, he requires no outside force to exercise it. Solomon uses his peculiar gift to baffle his family and friends. But it really comes in handy when he is menaced by a one-eyed cat who is determined to transform *him* into a rabbit stew. There are certain laws of nature that even magic cannot transcend, and when the frustrated cat drives Solomon, in the form of a nail, into the side of his house, the rabbit is unable to switch back. As Solomon contemplates eternity as a nail, a providential fire burns down the cat's house and frees him. He escapes to his family and reveals his secret to them, promising to use it in emergencies only.

If Solomon and Sylvester are cousins by catastrophe, Irene in *Brave Irene* (1986) is related to Pearl of

Solomon Rabbit has the uncanny ability to change himself into a nail, and he uses his talent to confound friends and family, until he comes across a cat who wants to turn *him* into dinner.

Solomon the Rusty Nail

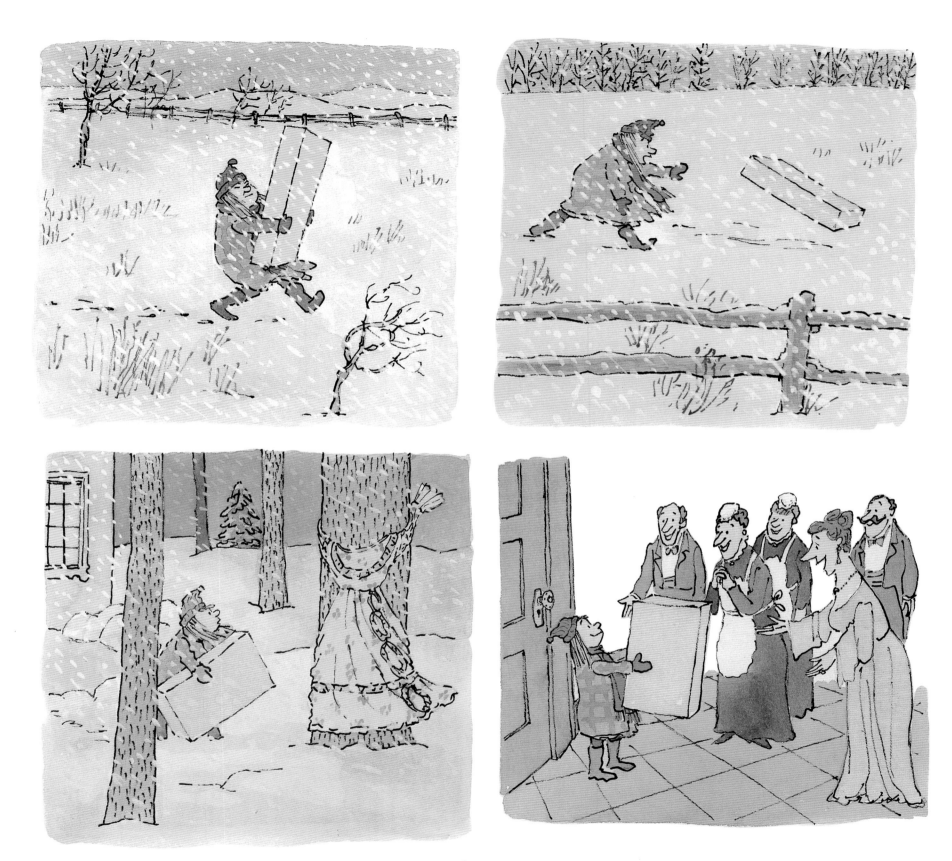

Brave Irene

The Amazing Bone by adversity. Using human beings in a picture book for only the second time, Steig spins a straightforward and heartfelt tale of heroism. The text is as lyrical as always, but it is the magnificent drawings that distinguish *Irene* from the artist's earlier books—all the more interesting due to the fact that, curiously, Steig did not intend to illustrate the book, and had written the story with Maurice Sendak in mind. Irene's struggle to deliver a ball gown in a blizzard is told in a series of drawings that are as powerful as a silent movie. One thinks of Lilian Gish making her way across a frozen lake in *Orphans of the Storm*. *Brave Irene* is best shared in front of the fire on an icy winter evening.

Nothing could be further from the poignant story of Irene than Steig's next book, *The Zabajaba Jungle* (1987). In fact, it's hard to find a parallel in anything Steig published previously, or since. *The Zabajaba Jungle* is as richly imagined as *Dominic,* as ferociously high-spirited as *Rotten Island,* and as sexually charged as *Gorky Rises.*

A young boy named Leonard finds himself slashing his way through a tropical jungle with his trusty bolo. Like so many of Steig's heroes, he is not quite sure how he arrived where he is. A synopsis can only hint at the pace and complexity of the plot. Leonard is menaced by strange plants and animals. He frees a butterfly captured by something similar to a Venus flytrap. He enters the gullet of a petrified monster and finds the innards engraved with many strange symbols. He emerges through the "cloaca"—a word not found in other books for children. He naps, and awakens on a carpet of snakes, but is carried to safety by the butterfly he saved earlier. A mysterious voice emerges from the forest and encourages him to

The Zabajaba Jungle

Brave Irene is determined to deliver a ball gown in a blizzard. In *The Zabajaba Jungle*, man-eating plants and menacing mandrills harass Leonard, the swashbuckling hero.

drink the nectar of a flower, which then lifts him into the sky. He jumps to safety, but is captured by four mandrills, who carry him to a tribunal. The tribunal is headed by three judges: a bird head, a rat head, and a snake head. He is about to be sentenced for transgressing the laws of the jungle when the mysterious voice urges him, "Show who you are!" So he sets off some fireworks that happen to be in his backpack, and his captors flee into the jungle.

Once more Leonard hacks his way through the underbrush. Suddenly he encounters his parents—trapped in an enormous bottle (a theme often used in Steig's earliest symbolic drawings). Leonard's dad is reading the paper and his mom is knitting. Leonard bangs on the glass but they don't seem to hear him. After failing to get their attention, he shatters the bottle with a rock. They rush out and embrace him. "Where are we?" his father asks. "In the Zabajaba Jungle," Leonard replies. "How do we get out?" his father says. "Follow me," answers Leonard. And so the book ends, the child now leading the parents.

A psychoanalytically inclined adult will surely read Leonard's story as a suggestive reshaping of the classic adolescent rites of passage. A child, unhampered

Spinky Sulks

by the habits of linear thinking, will discover delights and wonders on every page. Steig seems to be able to enter his subconscious the way the rest of us walk into a closet. It's interesting to note that this fascinating book is dedicated to the widow of his younger brother Arthur, who shared the same gift.

After the perplexities of *The Zabajaba Jungle, Spinky Sulks* (1988) is refreshingly straightforward. The cast of characters is once again human. Spinky feels, as do all children at one time or another, that his family misunderstands and underestimates him: "No one seemed to understand that he was a person, with his own private thoughts and feelings, which they couldn't begin to appreciate. The world was against him, so he was against the world, and that included all living things, except of course the animals." After two days and nights in his hammock resisting the blandishments of his siblings, his parents, his pals, a hired clown, a passing parade, and even his favorite grandma, Spinky suddenly decides to give everyone a second chance. He prepares a surprise breakfast for the whole family, and, without expecting miracles, hopes that the future will be better. From "Small Fry" and "Dreams of Glory" to *The Agony in the Kindergarten,* Steig has demonstrated an empathy with the traumas and triumphs of childhood unmatched in the graphic arts, and just about anywhere else.

William Steig's most fruitful relationships have always been within his own family. It's perhaps unsurprising then, that as his involvement with children's books deepened, he drew his editors into a relationship that can only be described as familial. Though Steig's career includes a steady stream of ideas and sketches traveling back and forth to his editor through the mail,

Zeke Pippin

the nitty-gritty of plot development, characterization, and to some extent the drawings themselves, are worked out in editorial conferences around the dining room table in the Steigs' Boston apartment. His editor at Harper-Collins, Holly McGhee, describes these sessions this way:

"I usually stay for one or two nights. We start working each morning after breakfast, around ten. The first book we worked on together was *Zeke Pippin* (1994)—the original title, believe it or not, was 'The Garbage Harmonica.' A musical pig, Zeke fishes a harmonica out of the garbage. He's magically able to play anything, but his music immediately puts people 'out like a light.' This curse turns out to be a gift that saves him from a gang of kidnappers and a ravenous coyote. Reunited with his family, he retires his sleep-inducing instrument and discovers that his audience actually survives his performances on a brand new harmonica, a homecoming gift from his parents.

"But I think a better example of our working methods would be a more recent book, *The Toy Brother* (1996). Bill had submitted the first of several drafts of this book to us back in 1977. It was then called 'The Alchemist's Son.' I came across eight different versions in our files. Each one had promise, but they didn't add up to a satisfying story. In some, for example, the older brother is too mean, and when he gets shrunk, or shrank, or whatever, the younger brother, who always wanted to be bigger, abuses him. The first version left

out the most important scene, the grand transformation, when the younger brother realizes that he in fact loves the older brother and really wishes to have the situation back as it was before.

"I read through all of these different drafts, and then I went to Boston and encouraged Bill to work on it with me one more time. We tried all kinds of things. Bill and I sat side by side with scissors and tape. We cut out the best parts of each version and we taped them together as we went along. Bill would fill up holes in the script by just making up stuff on the spot. (At one point we even tried shrinking the whole family.) When we were finished, we read it together out loud. We couldn't believe it. It had taken nearly twenty years, but we finally had a great story."

The Toy Brother

If *The Toy Brother* took twenty years to write, Steig's most recent book, *Pete's a Pizza* (1998), was delivered at a speed to rival Domino's. McGhee explains, "I'd gone to Boston and worked with Bill on a story about a witch turned into a fly. We worked on it all day. Then we just sat and looked at each other and said, 'This stinks,' so we just put it away.

"Now this is why I think of Bill as such a professional. He didn't blink an eye. Most authors are so tied to their stories that they feel it is a kind of criticism if it doesn't work out; a sort of personal insult. Not with Bill. For the next few days, we went shopping, went out to dinner, sat around talking, or did the *Times* crossword puzzles—anything but work on the book. Finally it was time for me to return to New York, and I said to Bill, 'I have to bring back something. What about your own children? Didn't you ever make up a game with your kids?' And he said, 'Well, I used to turn Maggie into a pizza "with everything." ' All of a sudden, there we were! Bill sat right down and rolled it out, complete with sketches. It's one of the few books he's turned in that required absolutely no revisions. In fact, the only hitch was the title. We had agreed on 'Petey Gets to Be a Pizza.' I went along with this because I thought Bill liked it, and it turns out he went along with it because he thought I liked it. At the last minute, we both agreed that it was terrible. After trying all kinds of variations, it was the designer's daughter who came up with 'Pete's a Pizza.' If you say it quickly it sounds like 'Pizza Pizza.' We all loved it."

How one creates a children's book is mysterious and at the same time simple. You take a pencil, a piece of paper, and you push words around until something

Pete's a Pizza, cover and rough sketches

Pete's a Pizza is based on a game Steig used
to play when his daughter Maggie was a baby.
He'd twirl her around like a circle of dough,
turning her into a pizza "with everything."

gels. Steig calls this process "mind doodling." In some cases, an image or turn of phrase seems to be the catalyst for him. For example, the phrase "goose hang high" was a catalyst for one of the images in *Dominic*. *Amos & Boris* grew out of a sketch Steig did of two whales lying stranded on a beach.

Although the creative process obviously starts with the artist, Steig is perfectly happy to concede the value of editorial opinion. McGhee has witnessed this generosity firsthand: "Bill once gave me a gift of some drawings, and in his note he said, 'Bless you for your good editing, even though it puts me to shame.' One of the pleasures of working with Bill is his love for new ideas. His attitude is always, Let's try something different. Let's go for it. Let's just do it. In *Grown-Ups Get to Do All the Driving* (1995), for example, it was Bill's idea to run the type in different colors on every page of the book. If something tickles him, he doesn't care who thought of it, it's always, 'Thank you, you're so brilliant, I love you.' Success has never gone to his head."

Like all artists, Steig has moments of divine inspiration, but like all professionals, he's bound by the constraints of the task at hand. Like all mortals, he begins with a rough outline and proceeds to a black-and-white dummy. McGhee says, "Bill doesn't do the color pictures until we're sure the whole story works. We move things around and make sure it all flows just right. We don't design the book until we're sure of the line count, and some things are redone up to the last minute. Coloring the drawings—the part Bill likes best—that comes last, like dessert."

In 1990, Steig created his most hideous and hilarious character in *Shrek!* If *Rotten Island* had housed bipeds, Shrek would have been one. Like the creatures in that accursed spot, Shrek revels in the whole range of his vile nature. His breath will broil a viper at ninety-nine yards, and he vents smoke from his ears just for the fun of it. Through his pores he emits fumes that cause flowers to wilt and trees to die. Still, every creature must have a mate, and with the help of a local witch Shrek finds his. When they finally meet, his heart melts and he expresses himself in verse: "Your horny warts, your rosy wens, like slimy bogs and fusty fens, they thrill me." His passion is reciprocated: "Your lumpy nose, your pointy head, your wicked eyes, so livid red, they kill me." Shrek and his gruesome sweetie marry and "live horribly ever after, scaring the socks off all who fell afoul of them."

In his splendid loathsomeness, Shrek is irresistible. Unsurprisingly, Steven Spielberg's DreamWorks has optioned the book and is creating an animated version. Typical of Hollywood's high-concept approach, DreamWorks has already created the Shrek doll, to be merchandised with the upcoming film.

At the same time Steig was working on *Shrek!,* he was beginning what would become a series of collaborations with his wife Jeanne. Their first effort, *Consider the Lemming* (1988), is a collection of short verses, a kind of bestiary in doggerel, written by Jeanne and illustrated by Steig. Jeanne describes the genesis of their joint projects this way: "We'd wanted to do something together for a long time. We'd made some puppets just for that reason. Bill's been nagging me to write some light verse for years. I chose this set about animals as a place to begin. Actually, we started to do another book, about the different ways people seek salvation—Zen, health spas, psychoanalysis, and so forth—but it was coming out smart-alecky, not funny.

Shrek!

Then one morning I woke up with a verse about an elephant in my head, and that got us started:

THE ELEPHANT

It's easy to identify
The elephant—I'll tell you why.
The elephant has tiny eyes,
Considering his mammoth size;
His tail is like a piece of string;
And there's another funny thing:
The ludicrously baggy pants
Peculiar to elephants.

I always show the verses to Bill to get his opinion, but he always says they're great. Then I show him four or five more versions, and he says they're great, too."

Jeanne has always been a prolific writer, and her output includes fiction, poetry, and plays. "I stopped writing when I met Bill, and he started. I decided that pointing was easier than talking, and sculpting was more like pointing than talking. Now it's fun to do both." So far the collaboration has produced, in addition to *Consider the Lemming, The Old Testament Made Easy* (1990) and a tongue-twisting alphabet in rhyme called *Alpha Beta Chowder* (1992). The couple has also exhibited together in Connecticut and New York, but the chances of another joint show seem remote. "I don't like showing," says Steig, assuming the implausible mask of a philistine, "it's not profitable."

Growing up with three brothers in "two beds and a crib," it's surprising that siblings rarely figure in any of Steig's cartoons or symbolic drawings—not even in *The Agony in the Kindergarten,* a book about the pain of childhood. Steig didn't tackle the theme of sibling rivalry until 1996, when he hit it head on in *The Toy Brother.* Alchemist Magnus Bede and his wife, Mathilde, have two sons, Yorick and his younger brother Charles. Yorick considers Charles "a pain in the pants" (a phrase Steig once used to describe his older brother, Henry), and tends to treat him that way. One day, as a result of fooling around in his absent father's laboratory, Yorick is reduced to the size of a mouse, putting him, literally, under Charles's thumb. Charles attempts to retrieve the situation, but at a rather leisurely pace, enjoying the role reversal. He builds a doll's house for Yorick to live in and feeds him table scraps. It's only after Yorick is beaned by a hailstone that Charles finally begins to treat the situation with some urgency. But despite Charles's

Consider the Lemming

The Old Testament Made Easy

AN APPETIZER FOR ALEXANDER

Abhorent axolotl, scat!
Unless you'd like to feed my cat.

Come at once, dear Alexander,
Have a bit of salamander.
See its tasty little gills?
Don't they look like lamb-chop frills?

Amphibian, avoid thy fate.
Slither off! Absquatulate!

ON THE BANKS OF THE NILE

The daughter of Pharaoh
Was thrilled to the marrow
When Moses turned up.
(He was cute as a pup.)

Crying "Isn't he luscious!"
She snatched from the rushes
This child of the Jews,
Who would later make news.

Alpha Beta Chowder

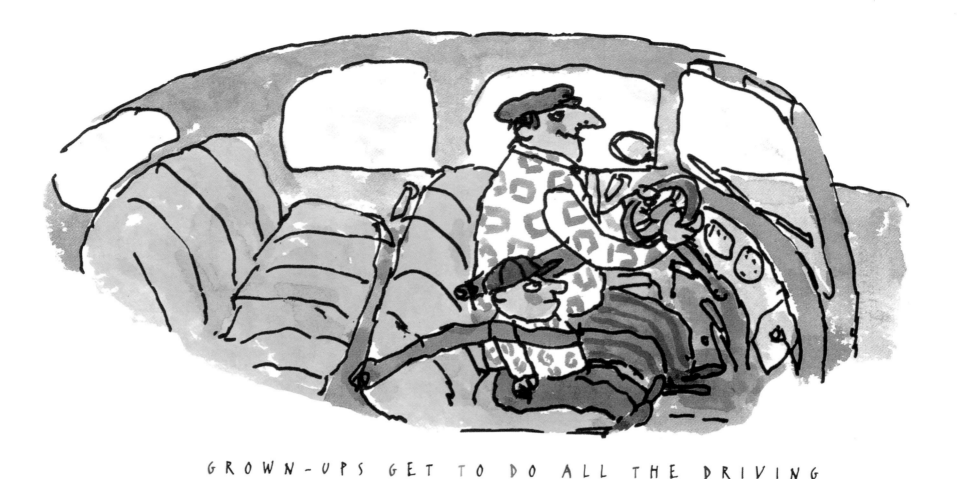

GROWN-UPS GET TO DO ALL THE DRIVING

frantic efforts, Yorick is still the size of a peanut when their parents return. Even Magnus Bede himself is unable to reverse the spell, until Yorick remembers the one essential ingredient in his transformation: ginger. With the help of a few magic words, Yorick is returned to his normal size. The family "went altogether out of their medieval minds. They hugged and kissed, wept and laughed, sang, yodelled, and then raced around like a bunch of maniacs." Yorick continues to dream of turning donkey droppings into gold, and Charles develops a passion for making dolls, all of which look like Yorick. "The two brothers sincerely appreciated each other now, except when they were having a fight."

Grown-Ups Get to Do All the Driving again demonstrates Steig's gift for experiencing life through the eyes of a child. A youngster's impatience with the seemingly arbitrary obstacles adults strew along the paths of his creativity is rendered in a series of witty and insightful sketches. A bow in the direction of "Small Fry," *Grown-Ups* brings Steig's art full-circle.

At ninety, Steig shows little sign of slowing down. He has already collaborated as an author with his stepdaughter on one book, the well-received *Toby, Where Are You?* and a follow-up volume, *Potch and Polly,* is on his desk. *Pete's a Pizza,* his thirtieth book for children, appeared in the spring of 1998.

GROWN-UPS GET HEADACHES

GROWN-UPS GET BALD

GROWN-UPS TAKE LIBERTIES

WORDPLAY

One of the many pleasures to be found in William Steig's books for children is the obvious delight he takes in wordplay. Silly names abound: The characters in *Dominic* include Elijah Hogg, a jackass, Matilda Fox, a goose, and Manfred Lyon, a mouse. In *The Amazing Bone,* readers encounter Yibban Sibibble, and in *Farmer Palmer* the thunder "dramberamberoand" and "bambombed."

Indeed, Steig's earliest books, *CDB!, An Eye for Elephants,* and *The Bad Speller,* are all essentially word games with pictures. The artist was tickled enough with these jokes to share them in letters to his young daughter Maggie:

[December 20, 1969]
What I like about stories is thinking up names for the characters. I think my mouse will be called AMOS.
I like your idea of using an anteater for a story. The other animals in the book could be a duck-billed platypus (as we said on the phone), an emu, a gnu, a cassowary, a gemsbok, an auk, a hairy mastodon, a wooly mammoth, a loris, and a two-toed sloth. We'll have to discuss this some day.

[May 15, 1970]
Eye sent yew a coppie ov migh boughk, "The Bad Speller," witch eye howp yew reseaved. It'z just a bitt ov vuling arownde, butt peapil seme two injoi it, igh'm gladd too saigh. Yoo coodn't dew this with enny langwidge eksept inglish, beekaus inglish haz difrint waze ov speling th saym thing. For example: through (oo), though (oh), thought (aw), rough (uff), bough (ow), etc. It will bee gould two sea yu agen, neckst weke-end; menewile:
A lott ov luv from awl ov uss—deer Magy,
Yore Daddee
Byl Stige

ANAMILLS PERFOURMNG
A DIFIKLT FEET.

R U O K ?

S, N-Q.

R U C-P ?

S, I M.

I M 2.

Four sum crayzee reezin, Wilyum Steyeg luvhs two hav phun wif wurds. Altho hee doughs knot addvokate bahd grahmer, sum ov hiz spelngs r troolee atroshush!

[May 2, 1972]
Zelda yelled "X-rated" when Vera undressed that Sunday. "Really quite pimply, oh naked madam! Leave Kansas. Join *Intelligent Healthy Girl's Federation.* Eat Doughnuts. Chew buttered artichokes." I like the alphabet game. It's challenging, because you just can't say what you want to say. You have to go where the letters take you.

Karla Kuskin, children's book critic and author of such classics as *The Philharmonic Gets Dressed* (Harper & Row, 1982), admires the artist's way with words: "*Yellow & Pink* is the children's *Godot.* When the 'man who needs a haircut' picks up the wooden philosophers and Yellow whispers to Pink, 'Who is this guy?' I collapse on cue. Steig recognizes and appreciates a good line, but he takes his responsibility as a storyteller very seriously. He never underestimates or idealizes his audience. And he relishes language, dropping in odd words and phrases the way an immigrant just learning English might. When the storm tosses Gorky in *Gorky Rises,* 'it was no frolic,' and as he floats about uncontrollably he wonders, 'What the doodad was keeping him up there?' Steig's ear is attuned to the strangeness of speech."

HEROES, VILLAINS, AND HAPPY ENDINGS

In the classic fairy tale, the hero slays the dragon and wins the princess. Heroes abound in Steig's universe—Dominic, Irene, Abel, Doctor De Soto, even Leonard in *The Zabajaba Jungle*—but they triumph by virtue of wit and character, not firepower. Their adversaries, as created by Steig, are not evil, but are merely unable to transcend the roles that nature has assigned them. It is the fox's nature to lust after pigs or mice, such as the succulent Pearl or the delectable De Soto (". . . to be savored with a dry white wine . . ."). It is in the character of the cat to pursue a rabbit (*Solomon the Rusty Nail*), or the owl to attack a mouse (*Abel's Island*).

This view of the world may not be as initially satisfying as the traditional cudgel on the noggin, but it is much more interesting, and even children realize it is much closer to the truth. Although it is pleasurable to

Doctor De Soto

The trials and tribulations of Steig's heros and heroines always end in a hearty embrace: In the words of Sylvester, "The loving looks, the fond exclamations—What more could they wish for?"

Solomon the Rusty Nail

see the quick-witted Doctor De Soto outfox the fox, does the fox deserve to be punished for being unable to resist the tug of his own nature? Steig says no. In his first picture book, *Roland the Minstrel Pig,* the fox does end up behind bars, but in all Steig's subsequent works

for children, retribution is passed over in favor of rehabilitation or reconciliation. Even the dastardly Doomsday Gang in *Dominic* are merely exiled, not destroyed, and the possibility that they, too, may win back a place in the natural universe is left open. In exchange for the cold satisfaction of revenge, Steig's readers are offered the warmth of reunion. Happy endings are, to paraphrase Tolstoy, all alike.

In the world of William Steig, bad luck, false starts, and wrong turns coexist beside sudden victories, redemptive love, magic palaces, and landscapes of great beauty. The challenges that are met and surmounted are presented as part of the rich fabric of life itself. Neither wealth nor fame, but the active use of one's senses is what gives life meaning. To live is to touch, taste, smell, see, and hear. Steig's heroes are passionately sensitive to love, beauty, and, above all, music. Through them, the great contradictions of this world are not resolved but transcended, and grown-ups learn again what every child knows—that life remains a baffling, but irresistible, (zabajaba!) jumble. Not a battle to be won, but a game to be played.

The Amazing Bone

Caleb & Kate

EPILOGUE

In an interview in 1988, Steig voiced frustration at the number of unfinished projects on his table. In particular he mentioned "a book to be called 'My Culture,' which would be everything that goes on in a family, society, just trying to define myself." A decade later, regarding his enormous output as a single work, it could be said that he has already written such a book. Certainly the lifelong concerns he first sketched out in his symbolic drawings and later articulated in both his notes on Reich and his introductions to his own books have been examined from every conceivable angle—in his cartoons, his covers, his drawings, and, most recently, his books for children. Has anyone in our time offered a more passionate defense of man's inherent decency, or spoken more elegantly of the transcendental nature of art?

Through the foreshortening lens of hindsight, there is a temptation to view Steig's own life as a kind of fairy tale. Surely it includes all the stock ingredients: a loving household threatened by an unpredictable reversal of fortune; the untested hero going forth to challenge the faceless dangers of the great world; the early triumphs and the flowering of natural talent in the rich soil of new lands; the decisive encounter with a magus; the mature years as a devoted son and brother, a loving husband, a nurturing father; and the rewards of fame and fortune that follow a lifetime of hard work. But William Steig is not a character in a fairy tale. He is a vital, passionate, sometimes difficult man who loves his wife, dotes on his grandchildren, frets over his taxes, and roots for the Giants. And he remains, in his ninetieth year, fully engaged in life, sending us, through the medium of his art, regular messages of loving regard, urging us to cherish the world and each other, urging us, again and again, to open our eyes and see.

Journey's End

ACKNOWLEDGMENTS

Without the wholehearted participation of the entire Steig family, this portrait of William Steig would have been little more than a rough sketch.

My greatest debt, of course, is to the artist himself and his wife, Jeanne. The recollections they shared with me were further enhanced by contributions from Bill's children, Lucy, Maggie, and Jeremy, and Jeanne's daughter, Teryl.

I also benefited from material offered by Bill's nephew, Michael Steig, and Bill's sister-in-law, Aurora, widow of his brother Arthur.

Beyond the family circle, I received valuable reflections on the artist and his work from a long list of colleagues and admirers. I particularly thank Ronald Searle, Robert Kraus, Maurice Sendak, Karen Savage, Stefan Kanfer, Ed Sorel, Jules Feiffer, Roz Chast, Ben Yagoda, Harrison Kinney, and Roger Angell. Karla Kuskin, Leonard Marcus, and Bill's children's book editor, Holly McGhee, occupy a special place on this list for permitting me to include their comments in these pages, as does John Updike, for his heartfelt introduction.

Sidney Levitt and Catherine Siracusa generously shared with me rare background information, as did Lucy Caswell of the cartoon research library at Ohio State University.

Robert Silverstone and Devereux Chatillon, old *New Yorker* colleagues, graciously permitted me access to the magazine's archives, and staff members Chris Shay, Bruce Diones, and Luis Rojas assisted me in the tedious business of locating and retrieving this material.

Miraculously, Suzanne Metral and Matt Lane transcribed my free-style longhand into legible copy.

I salute my agent, Martha Kaplan, for discovering the best possible home for this project, and I thank my publisher, Peter Workman, for providing me with the best possible production team. My editor, Siobhán McGowan, and my art director, Susi Oberhelman, overcame all obstacles with a combination of resourcefulness and good cheer rarely found in publishing—or anywhere else.

Finally, a large bouquet of forget-me-nots to my wife Jill and my daughter Ava for keeping a candle burning in the window while I toiled in the studio. It's good to be home.

BIBLIOGRAPHY

1932 *Man About Town.* New York: Ray Long & Richard R. Smith, Inc.

1939 *About People.* Introduction by Arthur Steig. New York: Duell, Sloane & Pearce.

1942 *The Lonely Ones.* Introduction by William Gibbs. New York: Duell, Sloane & Pearce.

1944 *Small Fry.* New York: Duell, Sloane & Pearce.

1945 *Persistent Faces.* New York: Duell, Sloane & Pearce.

1947 *Till Death Do Us Part.* New York: Duell, Sloane & Pearce.

1948 *All Embarrassed.* Introduction by Arthur Steig. New York: Duell, Sloane & Pearce.

1948 *Listen, Little Man!* by Wilhelm Reich, illustrated by William Steig. New York: Farrar, Straus & Giroux.

1950 *The Agony in the Kindergarten.* Introductory poem by Arthur Steig. New York: Duell, Sloane & Pearce.

1951 *The Rejected Lovers.* New York: Alfred A. Knopf.

1953 *Dreams of Glory and Other Drawings.* New York: Alfred A. Knopf.

1963 *Continuous Performance.* New York: Duell, Sloane & Pearce.

1968 *CDB!* New York: Windmill Books.

1968 *Roland the Minstrel Pig.* New York: Windmill Books.

1969 *Bad Island.* New York: Windmill Books.

1969 *Sylvester and the Magic Pebble.* New York: Windmill Books.

1970 *The Bad Speller.* New York: Windmill Books.

1970 *An Eye for Elephants.* New York: Windmill Books.

1971 *Amos & Boris.* New York: Farrar, Straus & Giroux.

1971 *Male/Female.* New York: Farrar, Straus & Giroux.

1972 *Dominic.* New York: Farrar, Straus & Giroux.

1973 *The Real Thief.* New York: Farrar, Straus & Giroux.

1974 *Farmer Palmer's Wagon Ride.* New York: Farrar, Straus & Giroux.

1976 *The Amazing Bone.* New York: Farrar, Straus & Giroux.

1976 *Abel's Island.* New York: Farrar, Straus & Giroux.

1977 *Caleb & Kate.* New York: Farrar, Straus & Giroux.

1978 *Tiffky Doofky.* New York: Farrar, Straus & Giroux.

1979 *Solomon the Rusty Nail.* New York: Farrar, Straus & Giroux.

1979 *Drawings.* Introduction by Lillian Ross. New York: Farrar, Straus & Giroux.

1980 *Gorky Rises.* New York: Farrar, Straus & Giroux.

1982 *Doctor De Soto.* New York: Farrar, Straus & Giroux.

1984 *CDC?* New York: Farrar, Straus & Giroux.

1984 *Yellow & Pink.* New York: Farrar, Straus & Giroux.

1984 *Ruminations.* Preface by Whitney Balliett. New York: Farrar, Straus & Giroux.

1984 *Rotten Island.* Boston: David R. Godine.

1986 *Brave Irene.* New York: Farrar, Straus & Giroux.

1987 *The Zabajaba Jungle.* New York: Farrar, Straus & Giroux.

1988 *Spinky Sulks.* New York: Farrar, Straus & Giroux.

1988 *Consider the Lemming.* with Jeanne Steig. New York: Farrar, Straus & Giroux.

1990 *Shrek!* New York: Farrar, Straus & Giroux.

1990 *Our Miserable Life.* Introduction by Albert Hubbell. New York: Farrar, Straus & Giroux.

1990 *The Old Testament Made Easy.* with Jeanne Steig. New York: Farrar, Straus & Giroux.

1992 *Strutters & Fretters.* New York: HarperCollins.

1992 *Doctor De Soto Goes to Africa.* New York: HarperCollins.

1992 *Alpha Beta Chowder.* with Jeanne Steig. New York: HarperCollins.

1994 *Zeke Pippin.* New York: HarperCollins.

1995 *Grown-Ups Get to Do All the Driving.* New York: HarperCollins.

1996 *The Toy Brother.* New York: HarperCollins.

1998 *Pete's a Pizza.* New York: HarperCollins.

FEATURED ART

INDEX

Page numbers in *italics* refer to art.

Editor: Siobhán McGowan
Designer: Susi Oberhelman
Production Director: Nancy Murray

Published in 1998 by Artisan
A Division of Workman Publishing Company, Inc.
708 Broadway, New York, NY 10003-9555

Library of Congress Cataloging-In-Publication Data
Lorenz, Lee.
 The World of William Steig/Lee Lorenz
 p. cm.
 ISBN 1-885183-97-6
 1. Steig, William, 1907– —Themes, motives.
2. Human beings— Caricatures and cartoons. 3. American
wit and humor, Pictorial. I. Steig, William, 1907– . II. Title.

NC1429.S583L67 1998
741.5'973—dc21 98-6962 CIP

PRINTED IN JAPAN

10 9 8 7 6 5 4 3 2 1

FIRST PRINTING

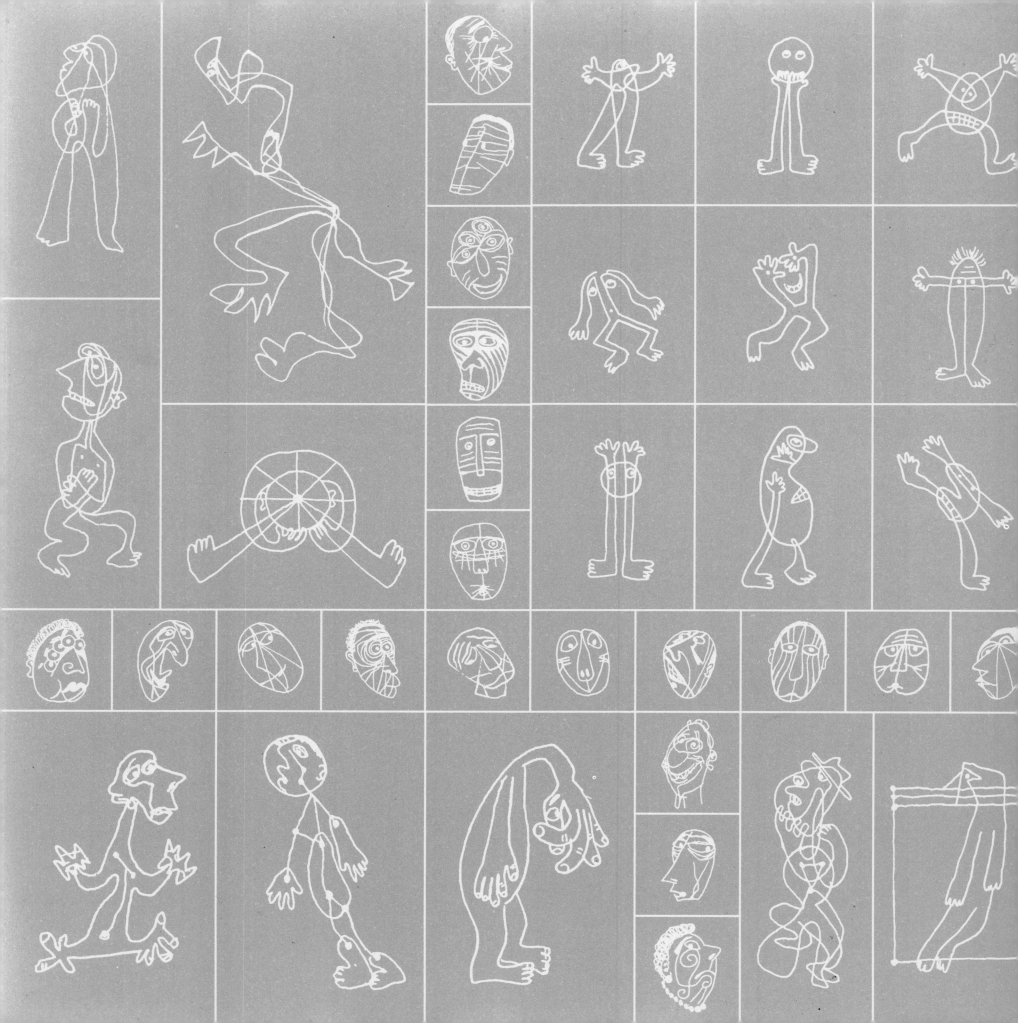